Anthony Caro

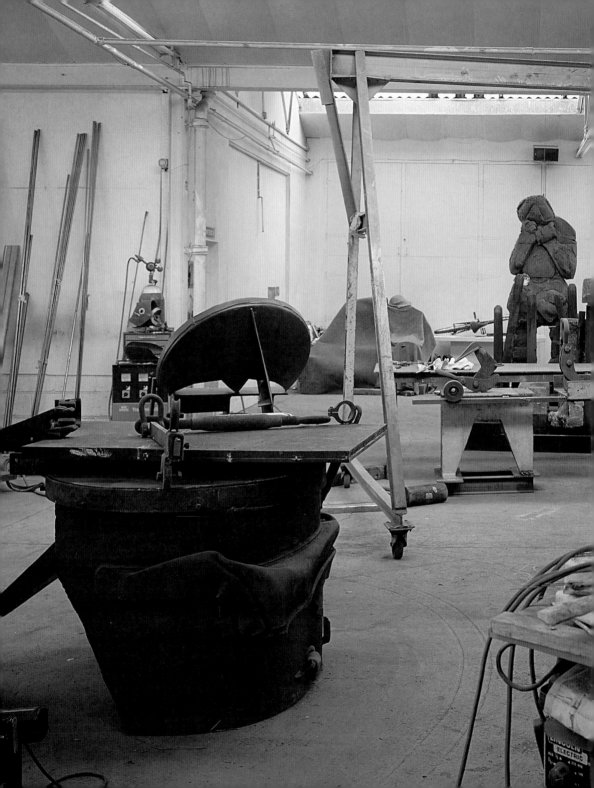

Julius Bryant

Anthony Caro

A Life in Sculpture

MERRELL
LONDON · NEW YORK

Acknowledgements

First published 2004 by Merrell Publishers Limited

Head office
42 Southwark Street
London SE1 1UN

New York office
49 West 24th Street
New York, NY 10010

www.merrellpublishers.com

Publisher Hugh Merrell
Editorial Director Julian Honer
US Director Joan Brookbank
Sales and Marketing Director Emilie Amos
Sales and Marketing Executive Emily Sanders
Managing Editor Anthea Snow
Editor Sam Wythe
Design Manager Nicola Bailey
Production Manager Michelle Draycott
Design and Production Assistant Matt Packer

British Library Cataloguing-in-Publication Data:
Bryant, Julius
Anthony Caro : a life in sculpture
1.Caro, Anthony, 1924–
I.Title
730.9'2

ISBN 1 85894 259 4

Produced by Merrell Publishers Limited
Designed by Maggi Smith
Edited by Matthew Taylor
Indexed by Hilary Bird
Printed and bound in Italy

Jacket front: *Early One Morning*, 1962, detail (see page 64)

Jacket back: Caro in his studio, Camden Town,
north London, 1989

Pages 2–3: The sculptor's studio, Camden Town,
north London, March 2004

The inspiration for this book came from a proposal from Sir
Anthony Caro to show a new group of works in London in
2004. He would like to thank, above all, the ceramicist Hans
Spinner. My greatest debt is, of course, to the sculptor him-
self, for trusting us at English Heritage to present his works
at Kenwood (his fourth exhibition in his local museum). In
this he has been supported by his wife, the painter Sheila
Girling. At the studio it has been a joy to visit Pat Cunning-
ham and the team of assistants – Ed Goolden, Hywel Living-
stone, David Bowen and Gary Docherty – as the sculptures
evolved. Tony's office managers, past and present – Fiona
Fouhy, Siri Fischer Hansen and Benna Harper – have been
most helpful in finding suitable images in the archive and in
liaising over the exhibition administration. I am particularly
indebted to Fiona for transcribing the recording of the long
interview. Ian Barker kindly shared some images from his
own research for his forthcoming major monograph on
Caro. David and Annely Juda generously sponsored a mem-
orable midsummer launch party in the Kenwood Orangery.

Hugh Merrell and Julian Honer at Merrell Publishers
responded with immediate enthusiasm to the idea of a book
to mark the exhibition in Caro's eightieth year, despite a
seemingly impossible deadline. At Merrell I am also grateful
to Nicola Bailey, Design Manager, Maggi Smith, designer,
Michelle Draycott, Production Manager, Anthea Snow, Man-
aging Editor, and Matthew Taylor, editor, for producing such
a handsome publication.

At English Heritage I should like to acknowledge the
support of Mark Pemberton, Dan Wolfe, Rebecca Kane, Wendy
Davidson, Cathy Power, Laura Houliston, Lisa Shakespeare,
Susan Baker and the custodians at Kenwood, without whose
faith and work the exhibition, and hence this book, would
not have happened.

Most of the photographs are by John Riddy, to whom I
am also grateful for his contributions to the design of this
book. On the home front, I am indebted to Barbara and Max,
yet again, for sharing my enthusiasm, a decade on from our
adventures with *The Trojan War*.

J.B.

Contents

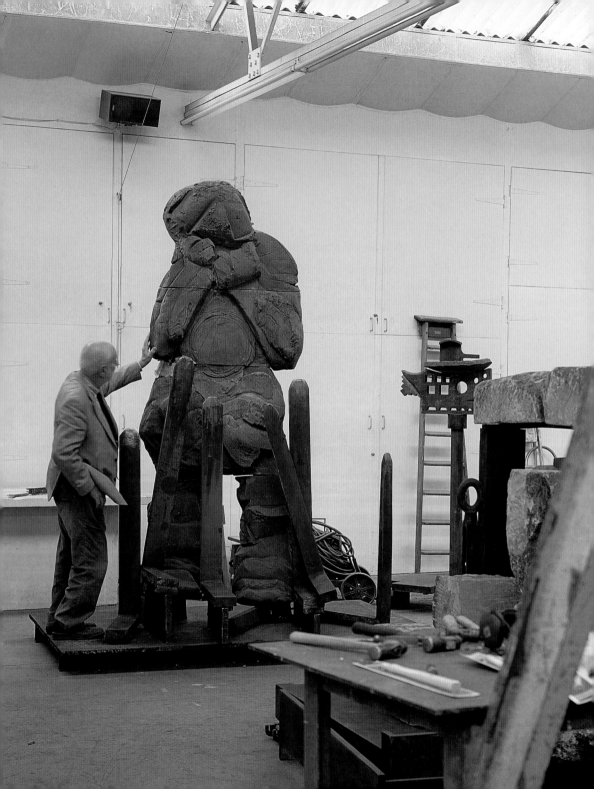

Introduction: Caro at Eighty

A short walk from the bustle of Camden Town Underground station in north
London, through tight twisting backstreets bisected by traffic thoroughfares, a rare
pair of quiet Georgian terraces stretches into a vista. Half way along, an arched
entrance leads down, past dark urban gardens, to the yard of an old piano factory.
Nothing suggests that this inner-city setting could be the source of some of the
most original and influential abstract sculptures to come out of Britain over the
past forty years. Nothing, other than a rusty stack of assorted steel sheets, girders,
rods, cones and a mountain of old railway sleepers, waiting to be awoken.

The wooden gate cut in the double doors of the factory entrance leads into the
workshop, where sparks from oxy-acetylene torches fly and bounce. Sir Anthony
Caro is dressed in his habitual tweed jacket, colourful collar and tie. With his close-
cropped silver beard, weathered complexion and stocky build, at eighty he has all
the energy and enthusiasm of someone half his age. Prolific as ever, he has nearly
completed a new group of sixteen sculptures and, typically straight-talking, he is
ready for a fresh set of eyes and an honest opinion. He hopes the new works may
have the makings of another one-man exhibition, his fourth, at his local museum,
The Iveagh Bequest, Kenwood, the Robert Adam villa that overlooks London across
Hampstead Heath. One corner of the studio is enclosed, as a dust-free, clean white
cube, a space to think with the eyes as new sculptures cool off. The door opens on
something that no one has seen before, that is like nothing anyone has seen before.

Caro is best known for his brightly painted steel sculptures, sophisticated
compositions in space that can be as intriguing as following the flowing lines of a
drawing by Leonardo or of a bacchanal by Rubens. With the opening of the Millen-
nium Footbridge across the Thames, designed with Norman Foster and Chris Wise
to link St Paul's Cathedral and Tate Modern with a "blade of light", Caro became
front-page news, as Britain's most respected living sculptor. Forever challenging
himself to take risks, to try different materials and work in factories and craftsmen's
studios overseas, once again he has reinvented his art. No one could have predicted
that Caro, at eighty, would tackle the most traditional of sculptors' ambitions, an
over-lifesize standing figure.

The white room is dominated by a colossal relief sculpture of a figure holding up its fists, its face in an agonized expression. The medium is baked clay, and the highest layers are toasted like the crusts of crude loaves of bread. Shafts of pointed steel flash up from below like flames or spears. We are far from the ideal realm of an antique *Apollo* or a Renaissance *David*. Caro's *Witness* burns the eyes with the pain of a Gothic crucifixion scene by Grünewald or the 'Horrors of War' and the 'Black Paintings' by Goya. The frontal format and closed pose draw our eyes into its surface, where the blunt mass seems to echo the figure reliefs of Matisse and the art of the Aztecs.

Caro explains that the figure was made flat on the floor in the studio of the ceramicist Hans Spinner, on the outskirts of Grasse, near Cannes, on the Côte d'Azur. It was then sliced up for firing. By using nearly sixty per cent grog (ground-up, pre-fired ceramic) rather than the fifteen per cent usually added to the clay to prevent solid forms from exploding in the kiln, there was no need to hollow out first. The lumps of clay (or "breads", as Spinner calls them) could retain their massy bulk, giving a primal, earthy character to the heavy components of the figure and to the physical marks left as the clay wrestled with the sculptor's own hands. The tonal range contributed by the firing process underscores the rich, gestural surfaces, almost as if Jackson Pollock had turned to sculpture.

At the feet of the colossus, adding to its sense of height, the remaining space in the room spins and accelerates through a series of low sculptures. Clearly they bear the fruit of that same working visit to Spinner's studio, of collaboration with a ceramicist who since 1975 has worked with some thirty artists, including Joan Miró. But since their arrival the great slabs of baked French clay, with the more literal exercises in modelling books, bottles and gourds, have been introduced to the metal *habitués* of Caro's studio, the survivors of scrap heaps and unfinished sculptures, hungry for fresh company. Each work defies ready comprehension. On the border between abstract compositions and portraits of laden tables abandoned by semi-distinct characters, none yields its answers from any one viewpoint. All lead eyes, mind and body around in search of angles and details that might provide some key, some means to help us to rationalize them into the conventional components of our prioritized three-dimensional world of objects, surfaces and supports.

At first sight the scene is one of devastation. The sculptures seem tight, even tortured, in their closed compositions, slow, weighty lowness and sombre tones, relieved only by the sensual qualities of curved clay. In mood they are closer to the late works of Rembrandt than to Picasso or Matisse. Caro's *Witness* seems insepa-rable, looking down on a broken landscape. The formal starting-point is clearly a series of tables. But each sculpture has evolved a distinct character of its own, one that is underscored by allusive titles such as *Summit Games* and *Aftermath*.

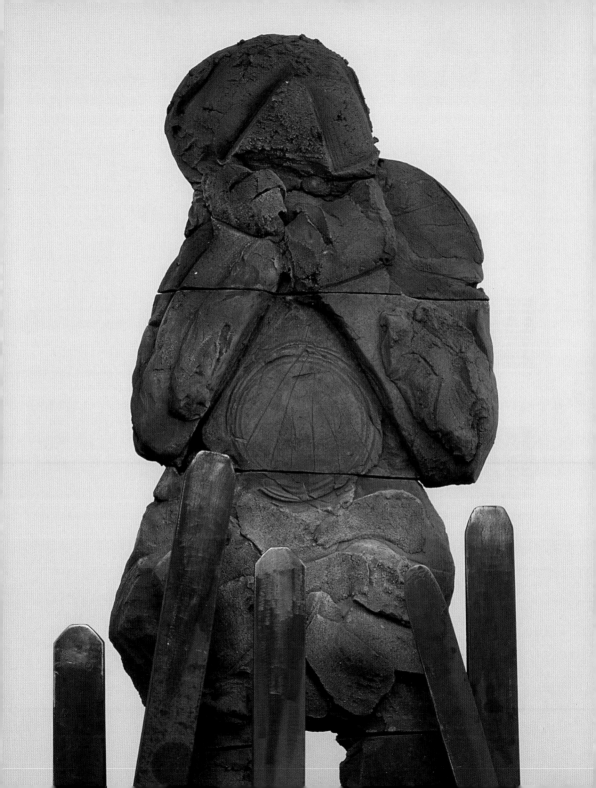

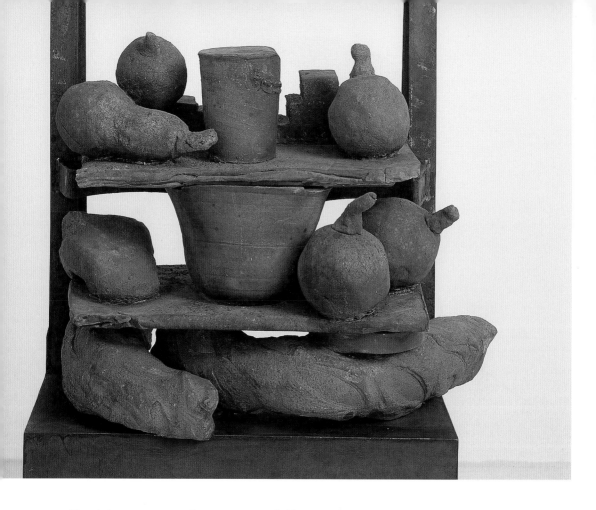

Provisions (detail), 2003–04

The obvious comparison, but one not intended by Caro, is with the ruins of Pompeii. The prosperous ancient community of merchants and shopkeepers lived in fashionable houses full of art and in colourful gardens beside the Mediterranean, their markets rich with the fruits of fertile vineyards, orchards, farms, flocks and fishing. This was the city described by Pliny the Younger as in "the loveliest regions of the earth", valued by Seneca for its "roses, wines and pleasures" and remembered by Cicero as "wealthy, well built, and beautiful". A city of bars, public baths, amphi-theatres, restaurants and wine shops that chose to erect, above all others, temples to the cults of Venus and Dionysus. A city that, in the midst of everyday midsummer life, on 24 August AD 79, was caught unawares by the eruption of Mount Vesuvius and then lay buried with its possessions beneath cinders for seventeen centuries. In 1759 (in a volume dedicated to William Murray, 1st Earl of Mansfield, then owner of Kenwood) the Scottish poet David Mallet evoked the devastation:

Ruin ensues; towers, temples, palaces,
Flung from their deep foundations, roof on roof,
Crush'd horrible, and pile on pile o'erturned,
Fall total – In that universal groan,
Sounding to heaven, expir'd a thousand lives,
O'erwhelmed at once, one undistinguish'd wreck!

Tempting as a comparison with the devastation of Pompeii may seem, Caro seeks a more universal and hopeful image of aftermath, one that cannot be embodied by any single historical event. No literal translation can sum up the psychology of confrontation that he explores. He invites us to discover, one to one, sculptures that reinvent in three dimensions the legacy of still-life composition left by Velázquez and Cézanne, works that accept no distinction between Surrealism and Abstract Expressionism.

Back in the larger studio, across the factory floor another door leads up a flight of steps. Within, the shelved walls are lined with a micro-gallery of Caro's œuvre, hundreds of toy-like miniature replicas of his colourful sculptures from the past

A corner of the studio

forty years and more. The shelves surround a central table, on which stands a scale model of some international museum's exhibition galleries, complete with a selection of sculpture, carefully positioned with tiny to-scale figurines specially made to help plan his next show. Here in this personal reference collection the precedents for the new sculptures may also be found.

In some of his earliest work, made in the 1950s, after he had been Henry Moore's assistant, Caro expressed in clay sculptures the sense of owning and operating a human body, of personal mass weighed down by gravity. An early photograph records him with the only direct forerunner of *Witness*, an over-lifesize standing figure that was too bulky to survive. By 1959 he had reached an impasse. Inspired by meeting Clement Greenberg, the American champion of such Abstract Expressionists as Jackson Pollock, David Smith, Adolph Gottlieb and Clyfford Still, and by visiting America, Caro chose new materials and found a new formal language. Moving from modelling clay over armatures to collage in industrial steel, particularly I-beams, Caro created some of the most iconic works of art of the late twentieth century, sculptures that now seem filled with the optimism of the 1960s and 1970s. Famously dispensing with the traditional pedestal, he placed sculptures

The models room at Caro's studio, March 2004

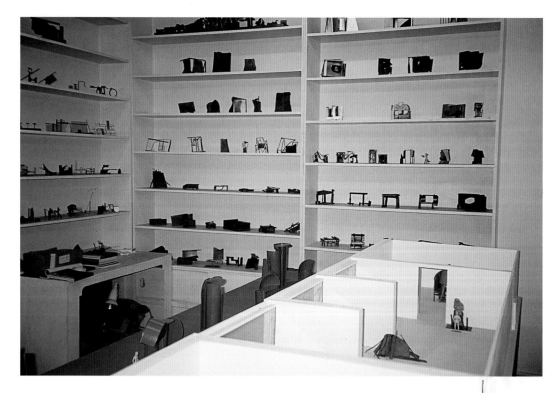

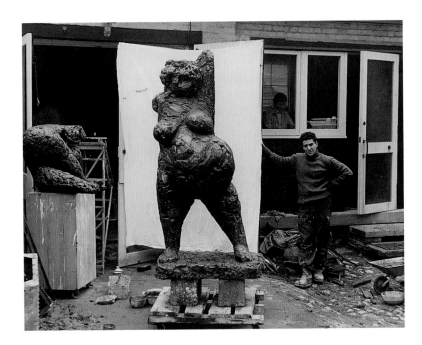

Anthony Caro outside
his north London studio,
1955/56, with *Woman in
Pregnancy*, 1955, and *Man
Holding his Foot*, 1954

directly on the floor, using the floor and walls of galleries almost as extensions of the sweeping planes and lines of the works, their compositions implying infinite extension into the space they penetrate. Putting sculptures on the ground also gave a new immediacy to the relationship between art and viewer, which Caro sought, for even in their non-figurative appearance they still addressed humanist issues, and spoke of experiencing the world as a fellow physical object.

Just as the use of clay and the 'return' to the human figure in *Witness* have their roots in Caro's early sculptures, so too does his choice of format for the new sculptures. Another critic, Michael Fried, encouraged Caro in the late 1960s in his exploration of the table edge as an alternative to the pedestal or gallery floor. Raised up, but visually unstable, these table sculptures could be smaller in scale, skeletal, and so present faster, dynamic compositions. Elegant drawings in space, they lead the eyes like swift dancers, seemingly ready to step gracefully free of the table's boundaries and into 'our' space. Following the example of some of David Smith's smaller sculptures, Caro soon incorporated found objects, such as blades, handles and pincers, that imply a more direct link with the viewer, like bizarre machine tools waiting to be operated. Caro returned to the table theme in the 1990s in a series of small pieces that question the over-familiarity of the tabletop, showing how the plane has edges, sides and height that link it to the floor; like walls and ceilings, these surfaces that we take for granted sandwich us in our daily lives.

A third theme that flows from his earlier work is the use of clay as a medium in collage. Caro used oily modelling clay in the 1950s, but turned away from it in the 1960s in favour of steel. There is a great tradition of artists working in synergy with ceramicists (it includes Gauguin, Matisse, Braque, Picasso and Miró), and the potential of a creative partnership drew Caro back to the medium. At Syracuse University, New York, in the 1970s Clement Greenberg helped Margie Hughto to bring together a group of Abstract Expressionist painters, including Larry Poons and Helen Frankenthaler, to explore ceramics. In 1975 Caro collaborated with Hughto in using stoneware clay, which is less pliable than modelling clay and forces the artist to work more swiftly before the slabs dry. Components cast from clay models, sliced pots and fired clay sheets were used to make sculptures where volume and voids, concave and convex forms, became more literal than in previous works made from steel.

Using his new stock of material back in London to make further sculptures, Caro found the medium invited a more reflective mode of composition, akin to that

The Moroccans, 1983–87

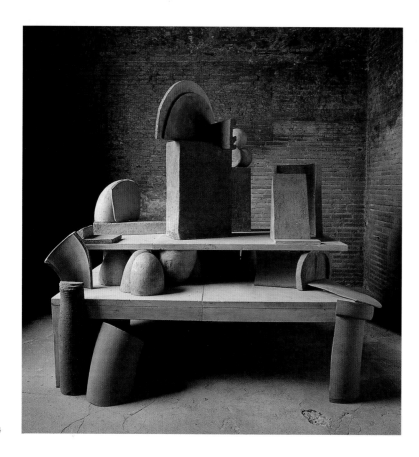

of the still-life painter. Between 1983 and 1987 he created *The Moroccans*, his largest ceramic sculpture to date. Inspired by Matisse's painting of the same name (1915–16; The Museum of Modern Art, New York), it combines old and new materials over a concealed steel armature, mixing the distinctive qualities of unglazed earthenware and stoneware to evoke the north African landscape. Caro further explored the potential of ceramics with Paul Chaleff at the Triangle Workshop in Pine Plains, New York, in 1989, making figures from soft clay cylinders. He collaborated again with Chaleff in 1991 and 1992 on the 'Hudson' series, an abstract group of more architectural pieces assembled from slabs and thrown elements of earthenware.

Caro's first visit to Spinner's studio, in 1993, revealed the potential of clay to take on more bulk and mass. This pursuit of physicality can also be found in the sculptor's use of vast sheets of raw untrimmed steel in the 1970s and 1980s. After that first visit to the Côte d'Azur, Caro returned to Camden Town, where, after firing, the shaped lumps of clay reintroduced themselves to him on a heroic scale.

The Trojan War, 1994, as installed in the Kenwood Orangery, 1994

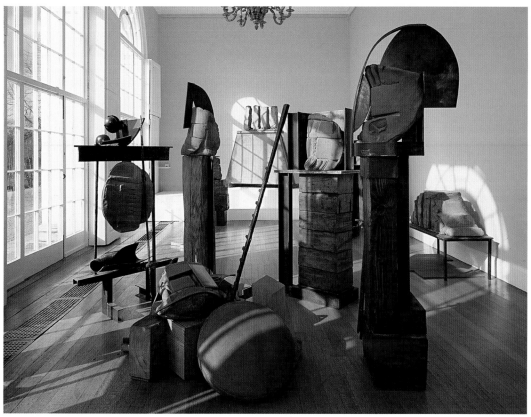

He had long sought to make an epic work, "a kind of *War and Peace* sculpture", and these abstract masses were soon set up on upright timbers and armed as gods and heroes in *The Trojan War*. Caro had worked in series before, exploring a specific theme, but rarely had he worked simultaneously on so many sculptures and never in a combination of steel, stoneware and wood. In the end, *The Trojan War* became an installation of forty works, a battlefield to walk through that was both his first narrative sculpture and, physically, his most ambitious work to date. First shown at Kenwood in 1994, it travelled to Athens, Thessaloniki, New York and Tokyo.

Caro returned to working with Spinner in 1995 to begin a series of stoneware 'Books'; enhanced by steel and brass, they look almost as if the words of many languages are wrestling their way into the pages. In 1998 for an exhibition at the National Gallery, London, he made five small 'Chairs', inspired by Van Gogh's painting of his own chair from 1888. The stoneware seats and legs were combined with other materials from his studio stock. Almost inevitably, their small scale evoked associations of childhood and innocence, and these have been explored in three related 'Chairs" made for the new group in 2004. In 1999 at the Venice Biennale he exhibited *The Last Judgement* (now in the Museum Würth, Künzelsau, Germany),

an installation of twenty-five sculptures. Here he responded to the atrocities of modern Europe, to man's inhumanity to man through social and political violence. Like *The Trojan War*, and the latest group of sculptures, they combine terracotta with other media and the complex art of installation, as a multi-part ensemble.

The new works differ from *The Trojan War* and *The Last Judgement* in showing a return by Caro to the theme of the table as an alternative to the pedestal, and his decision to integrate the tables fully into the sculptures. This may be more than a formal solution as, inevitably, tables are laden with symbolism, intended or otherwise. Tables are places of union, debate, work, study and even shelter. All artists echo the spirit of their age, and these new sculptures, while seeming to evoke the destruction of Pompeii, may be seen as presenting a metaphor for our own times. In contrast to the tall gods and defiant heroes of *The Trojan War* (described by Caro as "full of blood, power, heavy with fate"), the new sculptures share a more troubled mood, less certain, more reflective, inward and shadowy. *Witness* looks down, like some primitive idol erected to absorb the global anxieties from 11 September 2001 and the subsequent 'War on Terror'.

Caro came to fame in the 1960s with his colourful radical abstract steel sculptures, but for the past decade terracotta has become his main creative fuel. His use of metal collage in the past has drawn comparisons with the sculpture of Picasso, Julio Gonzalez and David Smith, but in these mixed-media multiple sculptural installations he has created an idiom that is wholly his own. At the start of the twenty-first century, when the pursuit of novelty and the illustration of ideas tempts some young artists with the superficial rewards of media exposure, Caro opens doors for those with the patience to look. For those dissatisfied with the cult of celebrity in the contemporary art scene he asserts the enduring potential of sculptural values, of composing in mass, void, surface, balance and tension, to surprise and intrigue. He invites us to explore with him the ways in which our eyes and bodies comprehend the physical environment we all share. As he looks forward to the next two decades of his career, Caro shares through his sculptures the sheer contagious energy that drives his compulsive making of objects.

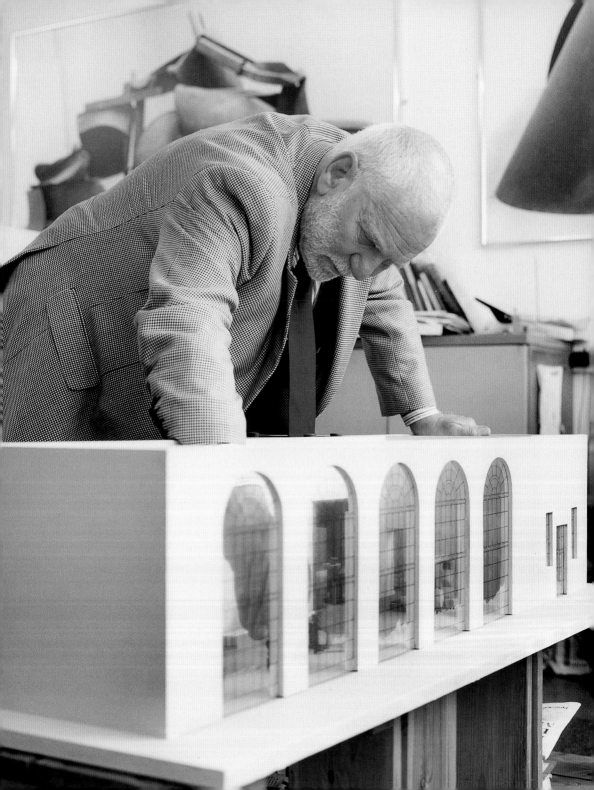

Caro in Conversation: New Sculpture

From an interview with Julius Bryant, recorded at Anthony Caro's
north London studio, Friday, 13 February 2004

Caro planning the installation
of his exhibition *The Way It Is*
in his scale model of the
Kenwood Orangery, 2004

How did this latest group of sculptures come about?

It started on a visit to the studio of the ceramicist Hans Spinner near Grasse
last year. I knew I wanted to make tables – shapes that were 'things'. Also I
wanted to do this one big figure, which I had thought of making in clay in my
studio here in London, and of casting in plaster. But I decided it would be less
of a physical problem to make it in terracotta with Hans. Working in ceramic
clay meant that it had to be made flat on the floor and then stood up, so it's a
sort of relief – a relief without a back.

Did you make the other new ceramic sculptures flat on the floor?

Yes. The 'tables' are all made flat on the floor. You simply cannot support that
much weight of clay standing it up.

**The actual pose of the figure reminds me of Goya's *Third of May* and his great
'Black Painting', *Saturn Devouring his Children*. Is it a homage to Goya in some
way?**

It's to do with that. I have been thinking a lot about Goya, looking at Goya
paintings and prints and reading books about him. But I don't want to be so
specific. It's about what Goya was about.

**The table pieces do seem to have begun as still-life compositions, in real life, as it
were, with their bottles, books and fruit. Were they made at the same time?**

I was at Hans Spinner's for a week. Works in ceramic clay have to be made
directly – if you make changes in the wet clay, it goes dead. So at that stage it's a
quick process. When the pieces dry, they are put into the kiln, and eventually
they come back to me fired, baked hard. The big figure needed to be cut into
parts in order to fire it, and then bolted together in London. In fact, all the
sculptures were put together in London.

Why a big figure? Had you seen a statue somewhere?

No. I thought, "why shouldn't I make a statue?" – to see whether one could do
it altogether afresh.

Are there perhaps memories of the African and Pre-Columbian sculptures that you first discovered through Henry Moore's library?

Maybe, but if anything it's more related to Picasso's *Man with the Sheep*.

Is the surface something that interests you in the ceramics, the way that in the firing they change? They look like they've been toasted.

I think the colour, the toasting, is of importance; when things are fired in a wood kiln, they come out with a very nice patina.

The table has been a formal theme in your work since the 1960s, but is this the first time you have explored it in ceramic?

I've never made tables in quite this way – they announce themselves as tables, not as levels. But then the steel sculptures that I'm making now are incorporating 'things' like presses and pulleys. In the past I've used parts made of steel; now I'm actually using things.

You've used utensils before.

Yes, but these were elements with a direction; directional, as opposed to being 'thing'-like, positive 'nouns'.

Is there a link between the standing figure and the tables other than the fact that they were made with Hans Spinner? How do the sixteen sculptures work together?

Over the past decade, since *Trojan War*, I have worked on some multi-part sculptures: *Trojan War* was forty pieces, *The Last Judgement* was twenty-five, *The Barbarians* seven. Within the groups each sculpture has its own identity. I have always been interested in exploring a formal theme or a new material, through working in series, but more recently the works have grown together rather than in succession. They feed off each other when you see them as one installation.

How far do the latest sculptures represent a new direction?

Ten years ago a new direction came into my work. It was almost as though *The Trojan War* knocked at my door and insisted on it. To get mass into my sculpture I had started to use lumps of clay. In the past I've taken explicit meaning or narrative out of sculpture as much as I could. My earlier sculptures were more like adverbs than nouns. Now we're in a more matter-of-fact time. We need some meat.

Your move to 'nouns' seems to be paralleled by your choice of materials, of terracotta, more than steel, in a move to physical bulk as well as subject-matter.

Spinner showed me how to treat terracotta as solid stuff, not in the way many ceramic potters go. They make a pot that has no inside. I don't regard any material as sacrosanct. I've now also put a stone sculpture in this show, which is about as solid as you can get.

How is this different from your work with clay in the 1950s?

In the 1950s I was usually trying to make a figure by building it up with modelling clay, which is much more oily. This is constructed over an armature. For

Control Point, 2003–04

Summit Games, 2003–04

example, the 8-foot-tall *Woman in Pregnancy* I made in 1955 (only the head survives) – there the surface is of pieces of clay put on. With ceramic clay, on the other hand, every touch counts. If you don't work fast, directly, you lose spontaneity and the clay dies. I have now got my speed comfortable, keeping that freshness. You work fast at Spinner's for a week with the wet clay, then it's baked. When the parts come here, they are hard and resistant. At that stage I work on them slowly, adding materials. You have another shot, and another shot.

You keep using steel, presumably because it lends itself to collage, unlike terracotta?
Yes, up to a point. You *can* stick bits of terracotta together. Some of the pieces in the new works are thirty-year-old off-cuts from when I worked in clay with Margie Hughto in Syracuse, New York. With Margie we made a 'piece pit', a vocabulary, a larder of clay parts to draw on. When I work with ceramicists, I'm not only making sculptures but also my own scrap heaps for later use.

The new works seem to be about the psychology of confrontation. Unlike the experience of meeting a person, a new building or a tree, they challenge the conventions of knowing where to look first, of distinguishing between the focal point and the background.

21

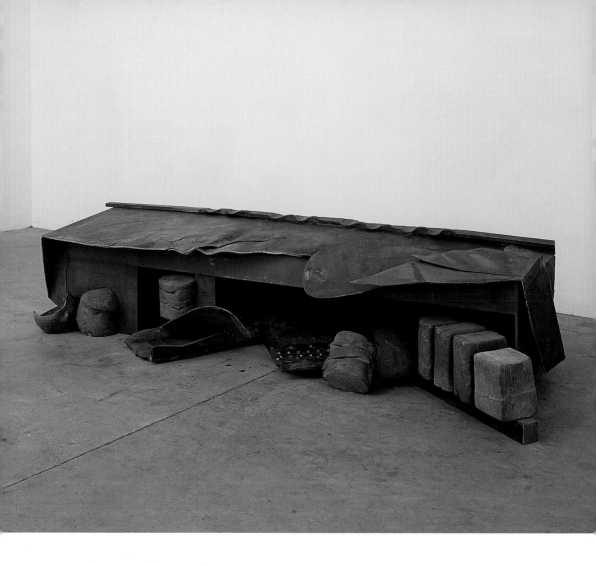

I've always wanted my art to be more real. It's not like giving a lecture from a podium; it's more like two persons having a conversation: the sculpture and the viewer. This is why I did away with bases as long ago as 1959–60, more in order to make the sculpture more immediate, one to one.

Are there other traditional characteristics of sculpture that you want to explore beyond?

All artists have a lot of history inside them, but you mustn't rely on it. Now I have my own history inside me, but I still want to surprise myself. I need to do something that gives me problems. These terracotta and steel sculptures are not what I normally do and so they give me hard days, something to get my teeth into.

Shelter, 2003–04

Monitor, 2003–04

Did the semi-outdoor setting of the eighteenth-century Orangery at Kenwood influence the finishing of the group and its development into an ensemble? Was it more challenging than the controlled environment of a modern art gallery's 'white cube'?

I'm not really concerned with the setting that my work is shown in. I've got to focus on the work's integrity rather than how it will fit a destination. That said, the Orangery at Kenwood is a marvellous place to show sculpture. I found the space successful when I did *The Trojan War* there, so I wanted to return to it – the great height of the room, its wall of windows, the vast views of sky and rolling lawns that it provides.

You began your career with very expressive figures and then made abstract, architectural sculptures. Now here you return to expression. What is the difference between your 'pure' abstract compositions and the humanism of these new works?

> Every one of my sculptures is about people and feelings. The difference between these more narrative works and the earlier abstract ones is like the difference between an opera and quartet. The expression in the opera is more overt. It may not be as 'high' a form; nevertheless, right now I feel the need for figures and real 'stuff'. You cannot go against your time. It's a narrow path, this allowing anguish in the figure without it going over the top and becoming kitsch.

Are you trying to say anything to the world with these new works, or are you making them primarily for your own satisfaction?

> I am not into propaganda, nor do I wish to offer moral lessons. I work for my own satisfaction, and I hope viewers will respond to what I have made. I try to get the sculpture right, the way it wants to go and the way I want it to go. That means living in the work. Whenever I try to do a public commission, like the Millennium Bridge or the sculpture over the doorway inside the National Gallery in Washington, I tense up. Commissioned public sculpture is not my world. I would like to make sculpture like Cézanne made paintings; that's a very personal, internal thing. I'm not in the monument job.

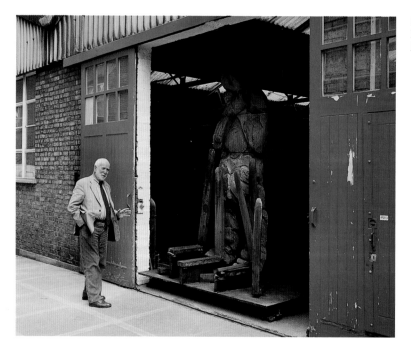

Caro outside his north London studio, with *Witness*, March 2004

So what's your Mont Saint-Victoire? What's the challenge you keep returning to?

It's been different at different times, like a series of hurdles. Since the 1960s sculpture has reinvented itself as high art, so I have been able to move freely through one problematic aspect of sculpture to another.

The choice of title always seems important to you; you are rarely satisfied with using just numbers for objects in series. Tell me something about the creative process of naming these pieces. Is it like giving each one its own identity, ready for life beyond the studio?

In this group the titles have been more significant for me than ever before. These sculptures, by getting their titles, have, I think, gained an extra dimension. I haven't noticed that happening so much in the past.

When *The Last Judgement* was shown at the Venice Biennale in 1999, it was compared to Picasso's *Guernica*. Parallels were also drawn with current events in Kosovo and the Balkans.

Not by me. Critics put things on to your work. Sometimes these add to or clarify the meaning; sometimes they make it too specific. But you can't escape the mood of the present time – even the images on the television news inevitably have some influence.

So the quality of a sculpture really lies in how it stands up independent of any associations?

You make your own associations, don't you? I think associations now are more relevant for me than when my sculpture was purely abstract. At that time there was very little association, and anyway I didn't like associations; they brought in a surreal or a literary aspect that I didn't want. I would have liked to make sculpture very abstract indeed. However, as time has gone on, I have begun to feel the need to anchor the work to everyday life. Titles are one kind of anchor; tools, utensils, are another. These new works include ceramic books, bottles and fruit made in Grasse but used once I got back here. But whatever associations there may be, the new sculptures are still, essentially, about looking at sculpture.

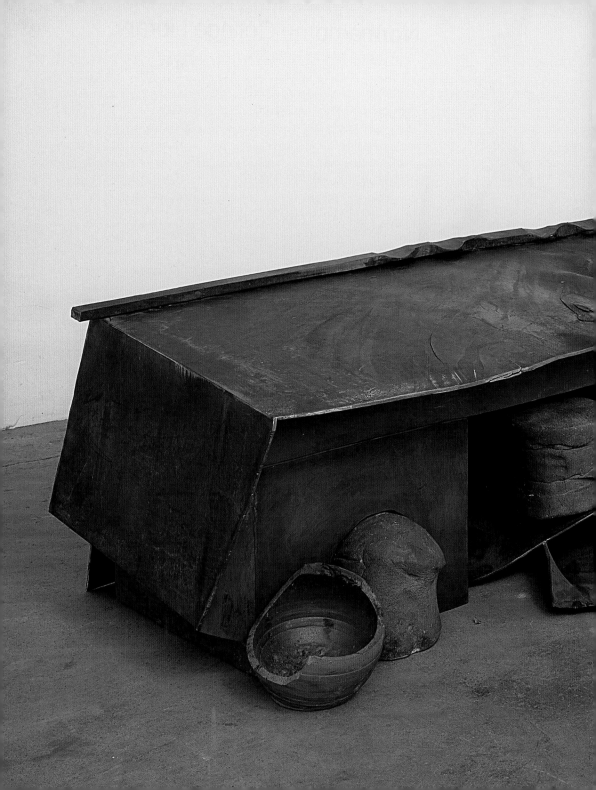

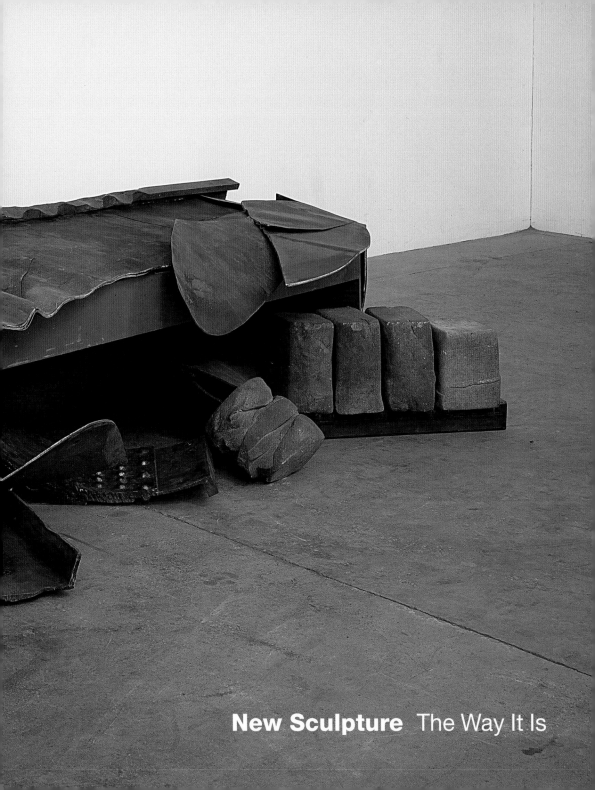

New Sculpture The Way It Is

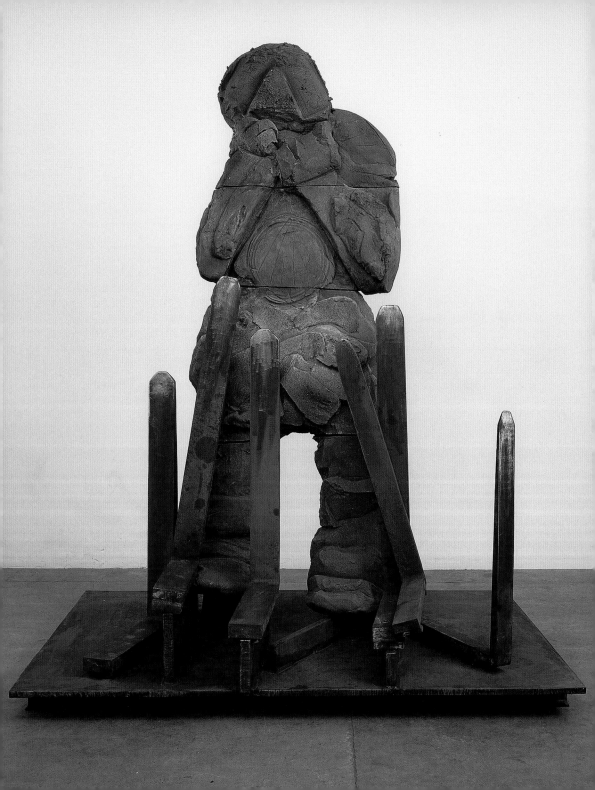

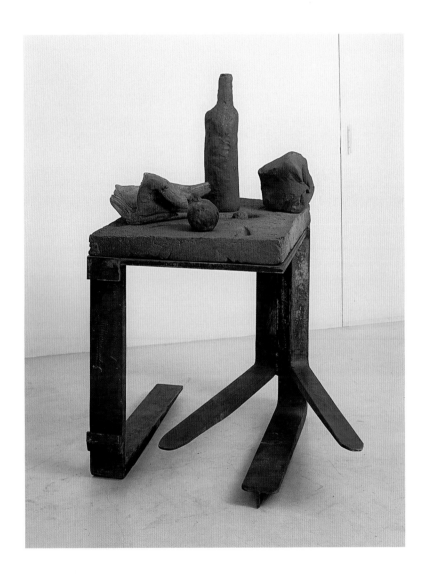

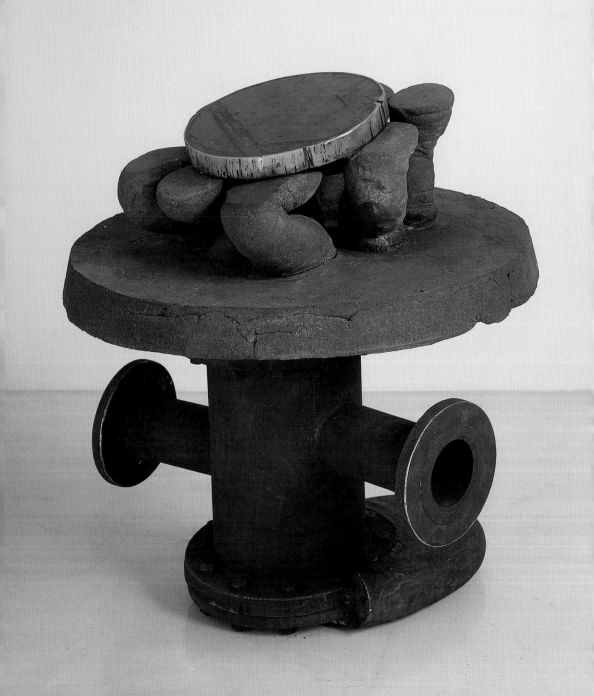

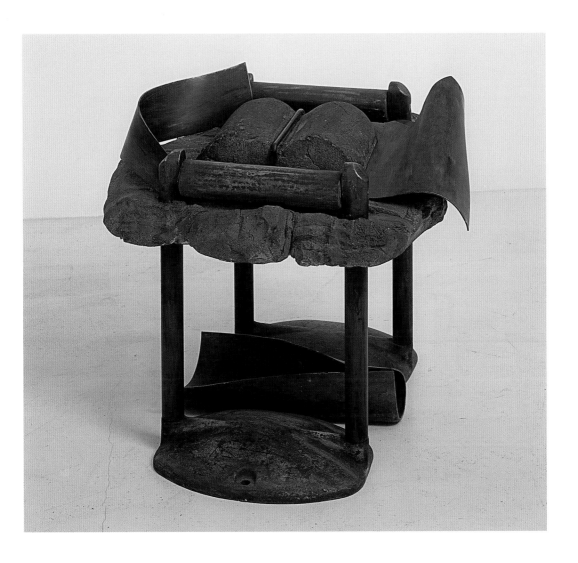

Bankers' Table, 2003–04

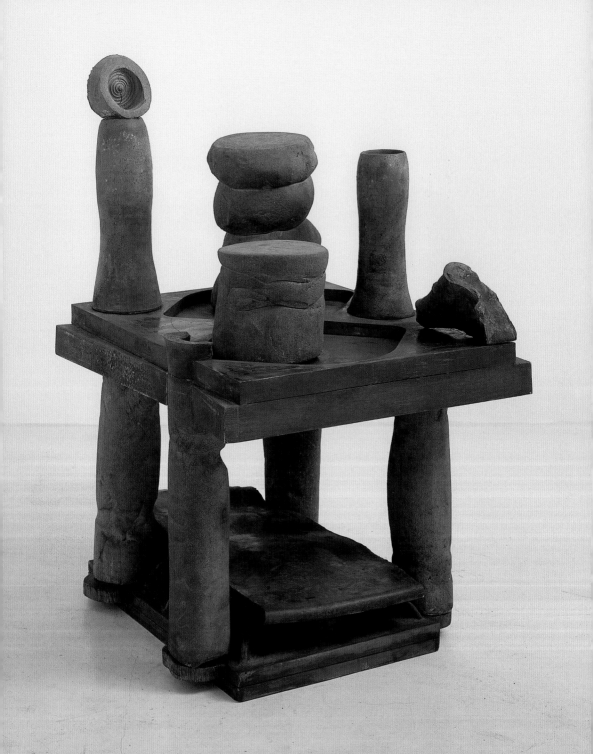

Summit Games*, 2003–04

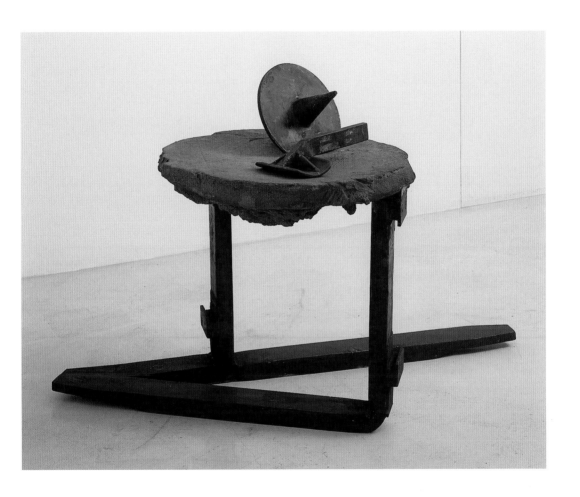

Aftermath*, 2003–04 33

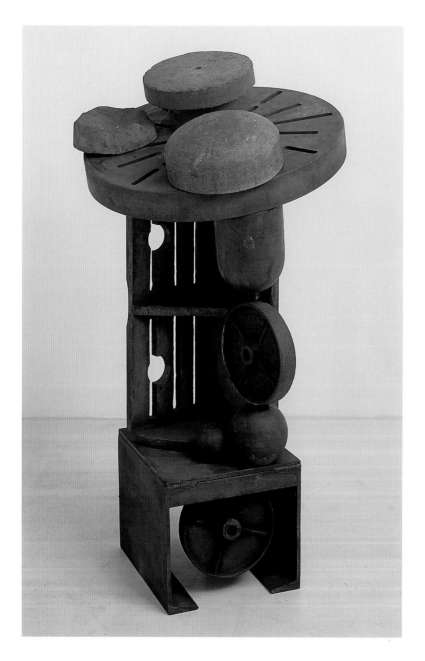

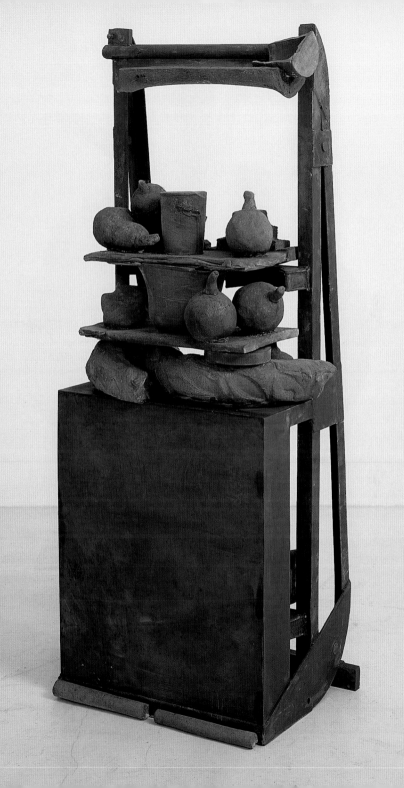

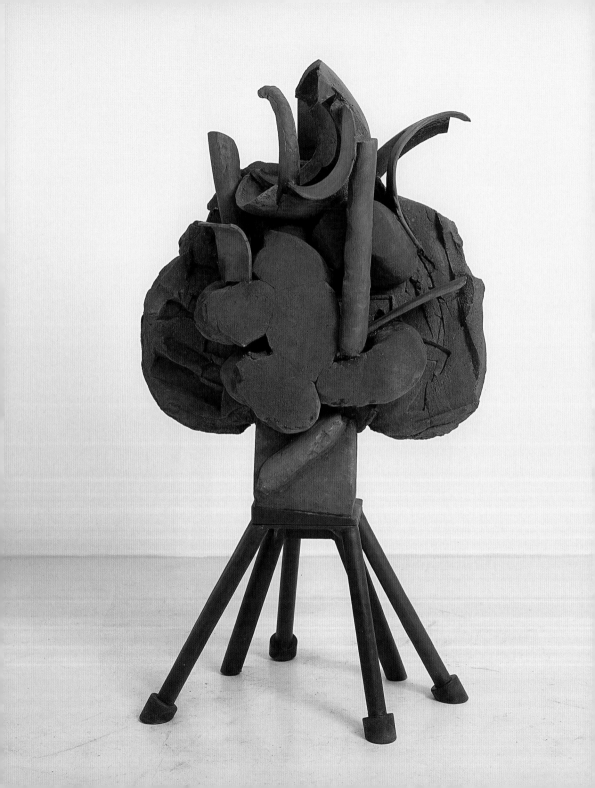

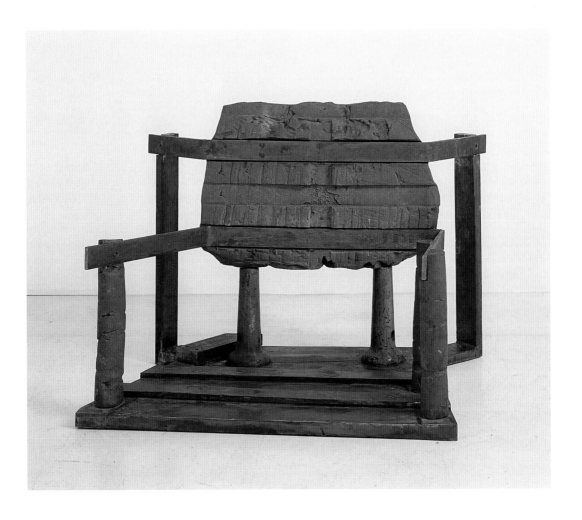

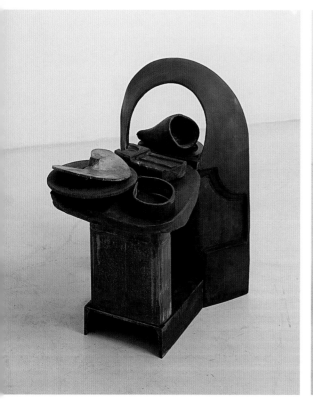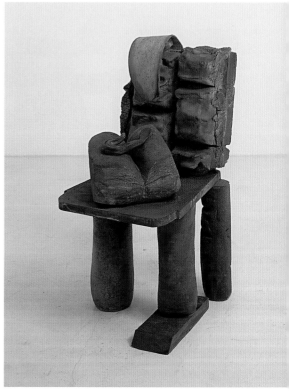

Children's Games, I, 2003–04 *Children's Games, II, 2003–04*

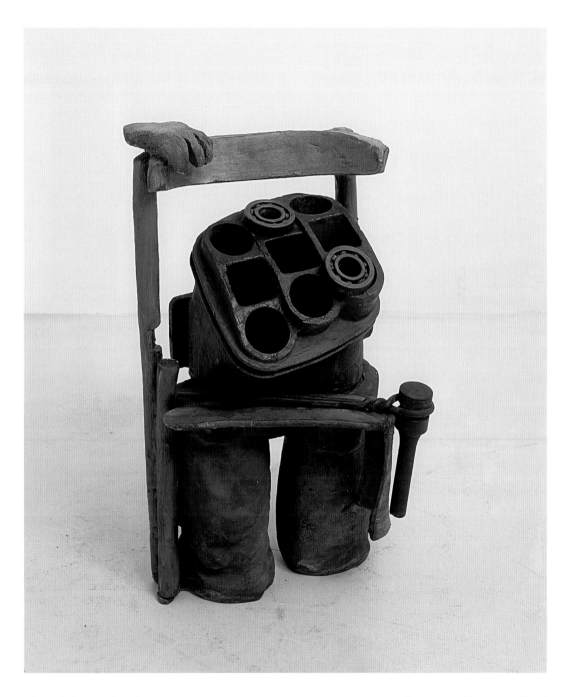

Children's Games, III, 2003–04

Pages 40–41: *The Palace*, 2003–04

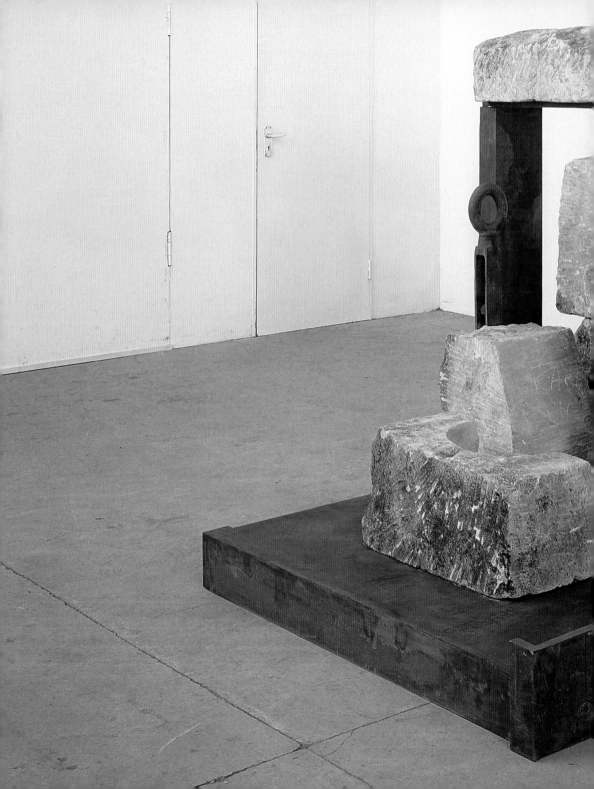

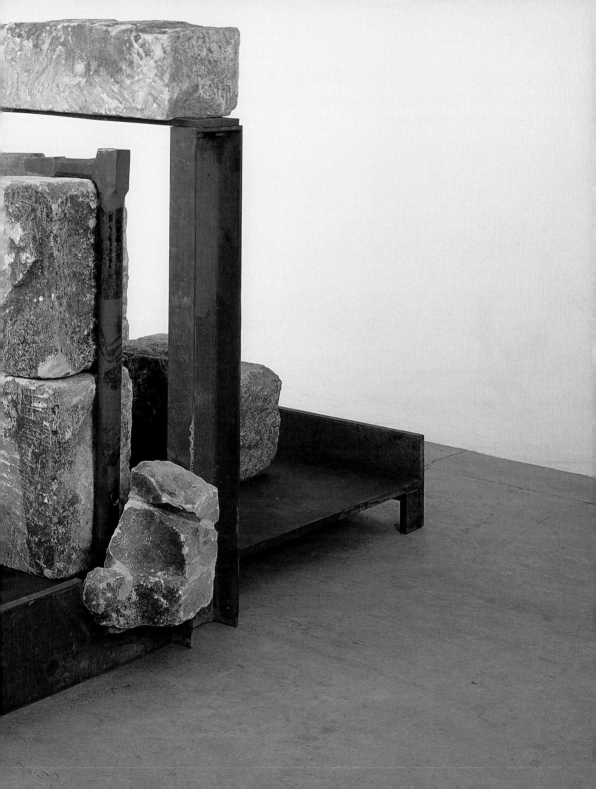

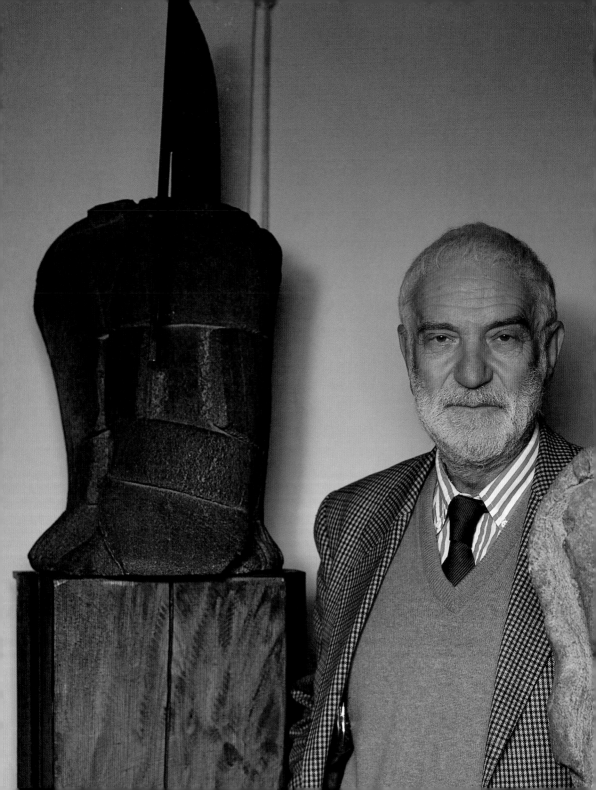

Recollections: A Life in Sculpture

From an interview with Julius Bryant, recorded at Anthony Caro's
north London studio, Friday, 9 January 2004

When did you decide to devote your life to making art?

My father was a stockbroker and he wanted me to go into his firm. I didn't
want that. Pretty early on I had decided that I wanted to be an artist, but my
parents thought that I had better get a training for a worthwhile job and sug-
gested I become an architect. I worked a little while in an architect's office but
didn't enjoy it, so I decided to try engineering.

**When you finished your engineering degree at Cambridge University, did you plan
to work as an engineer?**

It was wartime and I went into the Navy – the Fleet Air Arm. After the war I
studied to be a sculptor at the Regent Street Polytechnic and at the Royal Acad-
emy Schools, which was a five-year course. In the last year at the Academy I was
working for Henry Moore. I met my wife there, the painter Sheila Girling.

What was interesting about the teaching?

The teaching was by practising artists, academicians: a different academician
every term, which meant we were exposed to different kinds of sculpture. For
example, there was A.F. Hardiman, who made the equestrian statue of Field
Marshal Haig in Whitehall, William Macmillan and Charles Wheeler, who did
the figures for the fountains in Trafalgar Square. Richard Garbe worked in
ivory, Siegfried Charoux in terracotta, as also Machin, who did the portrait of
the Queen (the one on the stamps). I enjoyed the variety and I learned a lot
about how to work in different materials. I also got to know the history of
sculpture – the Greeks, the Romanesque and so on.

**And that interest in the whole history of sculpture really expanded when you went
to work with Henry Moore?**

That was a different part of history – yes, very much so. That was Surrealism
and Cubism and Negro art, which I hadn't ever seen before, and Oceanic art. I
used regularly to take books out of his library and read them, look at them.

What did you actually do? Were you his technician in some way?

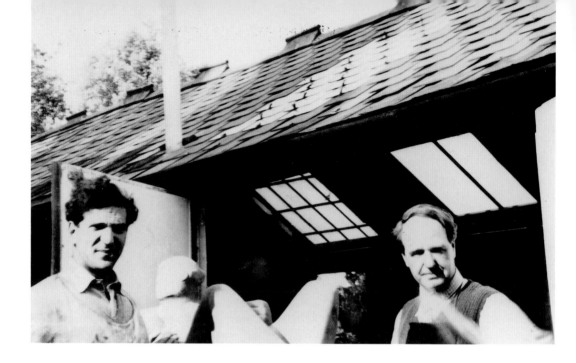

Caro at Henry Moore's studio, Much Hadham, Hertfordshire, *c.* 1952

I wasn't ever sufficiently expert in technique to be his technician. My work would encompass anything, from meeting Mary after school, working on small waxes with Henry or enlarging sculptures, or driving Henry into London. There is an immense amount of fabrication to do as an assistant to a sculptor. A sculptor can sketch something in quickly, but to make it hold together takes time. That's why we all have assistants in sculpture.

So you drove him to London from Much Hadham and then back again in the evening. What did you do in the daytime?

I went into the Royal Academy Schools to draw. At the RA Schools I was taught by painters, and the way they saw the model was a painterly way. They flooded light across the model, so they drew in the style of Ingres. There was no sense of volume. I could not see how drawing could fit with sculpture. When I got back to Much Hadham, Henry would look at the work and give me a critique. He'd say, "you're not expressing the two shoulders, you're not showing how they work together; this one doesn't belong with the other. You haven't decided where the light is coming from, you haven't expressed the volume by using the light" and so on. He was very logical. It was a very good training.

He showed you a sculptural way of drawing? In three dimensions?

Very much so. And I have many of my drawings with his little demonstrations on them, expressing how what is further forward needs to be bigger, and so on.

And what sort of person was he?

A very nice man. When I knew him, in his fifties, he was full of fun and we got along famously because he could see that I was really in love with sculpture. We had plenty to talk about.

Was he as interested as you in the contemporary American scene?

Oh no, and at that time *I* wasn't at all interested in the contemporary American scene; I had no idea of it! We'd talk more about Michelangelo or Rubens, past art history.

Were there living artists that interested him?

Yes. We talked about Marini a little bit. Also about the younger ones – Armitage, Chadwick and Paolozzi – but by and large Moore was much more interested in the distant past.

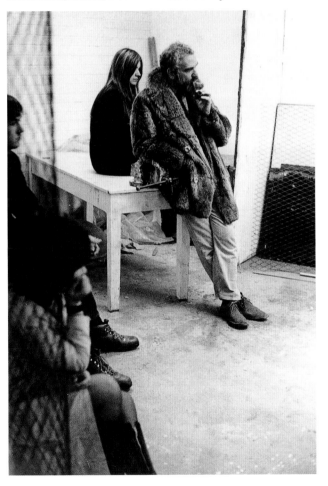

Caro teaching at St Martin's School of Art, London, 1960

In 1953 you took up a part-time post at St Martin's, teaching sculpture and drawing. Were you brought in to run an existing course?

The course was run by Frank Martin, who was the head of sculpture. I had met Frank when he was a mature student at the Royal Academy, and when he became head of the sculpture department he offered me a job. I went in twice a week in all those years until 1979. In the beginning I used to get the students to work from the figure during the day and in the evening to draw. I would try to make them grasp drawing in a sculptural way. For example, I would try to get them to understand the model, where the weight fell and so on, and then after looking at the model go into another room to make their drawings. I would get them to draw it full-size on a sheet of cheap lining paper so that they made a 6-foot-high drawing. I would use the same model that we had used in the day. These were all things that hadn't been done before. In the old days, if the sculpture students

45

wanted to draw, they would go to the painting school. I said, "make it part of sculpture". Later on evening classes involved all sorts of experimental work. Frank Martin used to hire former students as teachers; so many people – such as Philip King, Tim Scott and Bill Tucker – became teachers. The department became more a workshop than a teacher/student situation.

Was there a sense or was it seen by critics at the time as being a St Martin's School group?

Yes. In contrast to other art schools, who were orientated towards a provincial, romantic way of thinking.

And what did you enjoy about teaching? What was the most rewarding part?

I've always enjoyed teaching. I like the idea of working with others. I've been to schools where the students are shut into their little 'inspiration boxes'; they are isolated and gain no stimulation from one another. On the other hand, I like the students more or less tripping over each other; they say, "give me a hand" and "what do you think of this?" I've always relished that sort of workshop situation because I think you give each other a tremendous lot; you can't get it

Caro receiving guests at his first UK one-man exhibition, Gimpel Fils Gallery, London, 1957. In the foreground is *Man Holding his Foot*, 1954

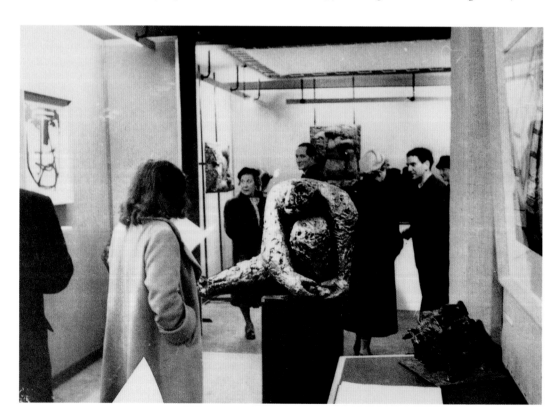

all from inside yourself. No doubt certain artists are extremely private but, as a rule, sculptors always need help lifting, welding, moving something.

And mutual criticism?

If the dustman had an opinion, I'd be interested. I've worked in factories and I've had communication with the workers, who have never seen a sculpture before in their lives. Your language can extend because of other people. My sort of sculpture is not private in that way: it's private in as far as it's intimate, but it's not private in the sense of being cocooned.

Your work at that time in the 1950s was figurative, expressionistic. You've talked about trying to convey the sense of being inside a body. But it seems to have become a bit of an impasse for you because there was such a dramatic change after you visited New York in 1959–60.

Sculpture is always to do with being in the body. The figurative works of the '50s were illustrations of that. But my early steel sculptures were, instead, a reflection of bodily behaviour, like dancing. I think the fact of being 5 feet 6 or 6 feet tall and the stretch of my arms are very important.

Clement Greenberg came to your studio?

He came to England and I met him at a party. He came to my studio, which at that time was the garage of my house. He stayed all day and we talked about sculpture: it was an eye-opener. When I went to America later that year, I met Clem again and saw a lot of art that was quite new to me and new also to my way of seeing. Anyway, I had got into an impasse with the body.

And did he feel that you needed to change in any way? Did he give you any specific guidance?

Clem's advice was never specific. He said, "if you want to change your art, change your habits". That was very Clem. Enough to make you think.

So you went to America. What was your first impression? You went to New York initially?

It was exciting. It was open. Not bound to history in the way that we are in Europe. It was very refreshing. I saw a lot of shows and I met artists who were welcoming and friendly: Helen Frankenthaler, Bob Motherwell, Adolph Gottlieb and Richard Diebenkorn; also Nevelson, Johns, Rauschenberg. Kenneth Noland was my age, and so we got along well. When I came back to New York, after visiting Los Angeles and Mexico, we met at the Cedar Bar and talked about art all night.

Did you see Noland's work in an exhibition?

I saw his first show of circles, at French and Company.

Was it more his ideas or his actual work that you found inspiring?

His personality; he was not 'clever', just straight-talking. I could never do

'art speak'. English artists were often able to explain the philosophy behind their work; I could not do that. Ken was like this too: a looker not a talker, artistically intelligent but not into words. The English art world had been very Paris-orientated, to do with Existentialism, Surrealism. But it seemed to me that that stuff was not what the subject was about. I was to do with making sculpture.

David Smith liked to play the straight-talking man. How did his ideas inspire you?

David was quite different; David went over the top the other way. He was actually pretty smart, intelligent. But he liked to say, "I'm just a welder". You couldn't meet an English artist who would say that. Mind you, it's also a kind of affectation: to be so intentionally blunt.

And did David Smith indeed look and act like a welder?

He was, physically, a big man, a lot older than me: eighteen years. David was quite friendly, kind. He was competitive with every other sculptor. But my work did call for his respect. He stood in for me when I first came to Bennington College, and he set up the school studio for welding. David was insecure: Henry put

Caro (who had broken his leg skiing) with (from left) Clement Greenberg, Jenny Greenberg, Sheila Girling and Kenneth Noland at Bennington, Vermont, 1963

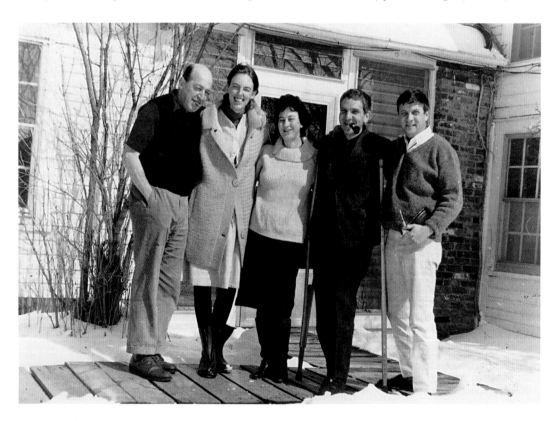

his sculptures out on show in his garden so *everyone* could see he was the greatest but David put his sculptures out so that *he* himself could see he was the greatest. He wasn't trying to persuade other people; he was trying to convince himself. His two fields at Bolton Landing with about eighty sculptures were a sight to behold.

So there was a real driving insecurity behind David Smith's sculptures?

I was told that even Pollock and the Abstract Expressionist painters thought that David was a country bumpkin. They didn't get how good he was.

Was there something about Smith's method of working, more than his choice of industrial materials, that interested you?

Yes, his approach was closer to the factory. For instance, he would make sculptures on the floor and stand them up – things like that, quite unexpected, absolutely non-art school.

It was Noland who gave you the idea of working in series, rather than Smith?

Yes, but he got that from David.

And the idea of working simultaneously on different works?

No, I don't think anybody gave me that. It's about the speed of working. While I'm away, my assistants carry on fabricating my pieces, and then I come back and take another look.

You told me earlier that meeting Noland gave you the new idea of showing sculpture on the gallery floor, rather than on plinths. Your works in the 1950s had been exhibited on plinths.

When I met Kenneth Noland in New York in 1959, he told me how he painted his target pictures horizontally on 'saw horses' (trestles) – he didn't paint upright at an easel. He worked this way to prevent himself being 'aesthetic'; he was trying to get what the paintings needed, not balancing or composing. In my one-car garage in Hampstead I worked on large pieces so that I couldn't see my sculptures whole. I had to get into them.

Can I ask you about other artists in New York, such as Alexander Calder? You once said that *Early One Morning* was influenced by him.

There was a show of his work here in London. There's some slight relationship as Calder uses red, as I do in that piece. I'm not a fan of Calder. There's something too elegant, fragile, in his work.

A well-known influence was the critic Michael Fried. He first saw in your table pieces the importance of the edge, rather than treating tables as another surface to work on. Was that an idea that you came to together?

Michael and I have always been able to talk about possibilities. Mike is great in the studio. You'd have quite different conversations with Michael from the ones with Clem in the studio. Michael is younger than me, but he is right into my sculpture and my thinking; we're always in communication.

Greenberg and Fried were really interested in the actual process of composition?

Yes, but with Clem you talked about the piece in front of you, never about ideas. Different ways of looking. Michael is in there thinking with you, Clem was looking at results.

Would Greenberg have been more judgemental?

Not judgemental, but giving criticism and encouragement.

Perhaps we can wrap up these early American years by talking about your teaching at Bennington College in Vermont from 1963 to 1965. Was that part-time or was it residential?

We lived up there, and I went to the college twice a week. Also I had a studio myself on the campus.

Was the main incentive for moving there to be close to David Smith, who lived 90 miles north?

Not at all. It was to be close to the college, also close to Noland and Olitski. We had visits from New York artists and critics all the time. The school was very forward-looking, the top liberal college. Of course, teaching there was a different thing from teaching at St Martin's. It was much less specialized. At Bennington the students would do a period of sculpture, then go off and study Chinese history or something. Seniors who only had a couple of weeks more would not decide their direction. It was a slower pace.

You taught in America for two years. Did it cease to inspire you in some way, or was it the sudden death of David Smith in 1965 that made you leave?

Although I love America and enjoy living and working in the States, I belong in the UK. Coming from time to time to America was better than being in America all the time.

You never felt you were becoming more an American than a European artist?

I was very close to American art. I still am. I feel comfortable in New York. I do not feel myself to be a European artist.

In 1969 your working premises in London expanded massively from a single-car garage to a former piano factory. Was this because you felt the need to work on a much larger scale?

Not at all. My intermediate studio in West Hampstead was going to be pulled down and Kasmin, my dealer, said, "I've come across a wonderful place, you ought to have it". I came and looked at it, thought it too big. He persuaded me. We are still here today.

It does seem to be a turning-point, for you worked on a much larger scale in the 1970s, particularly when visiting factories.

I never worked on those sculptures in my studio. I haven't got the equipment.

What sort of technical facilities do you have here?

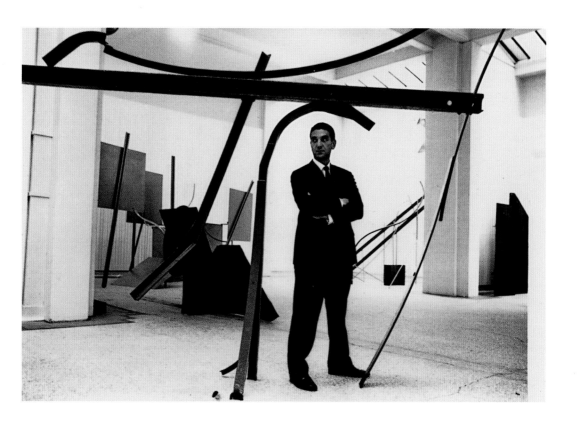

Caro at his retrospective
exhibition at the Whitechapel
Art Gallery, London, 1963.
In the background (from left
to right) are *Pompadour* (1963),
Twenty Four Hours (1960)
and *Month of May* (1963)

At that time I had nothing. However, I had good help from Charlie Hendy in those days and then from Pat Cunningham, who has been with me for thirty-five years.

Pat Cunningham is a professional welder? That's his skill, rather than a sculptor?

He's an engineer. We were really very low-tech. I work with what I've got, but when I went to factories – in Toronto, for example, where they have heavy steel and heavy equipment – I would use those, which would be great and would open a new door for me.

Let's talk about the 'Flats' series from 1974, made at the York Steel Co., near Toronto, from vast sheets of soft, unfinished, untrimmed rolled steel. I was wondering to what extent they gave you the opportunity to work like the American Color Field painters, such as Olitski? The sheer scale and weight, the need to work at a distance from the piece while it's suspended on a crane, must have forced you to make quicker, even spontaneous, decisions?

It was wonderful. I worked very fast. I would say, "hold it there, now tack it". I'd try and get one off the pad every day as my pad was not big. I had perhaps 51

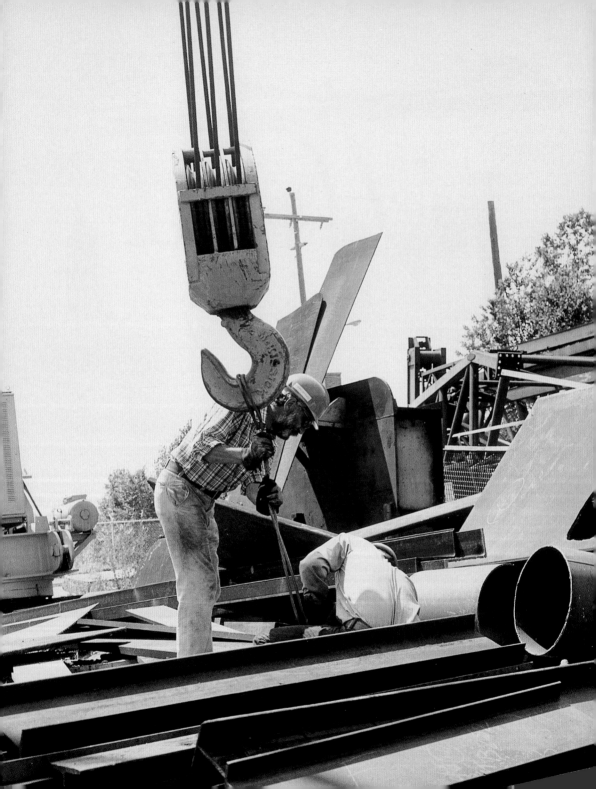

three or four pieces unfinished. I didn't keep reconsidering. The works were put aside, and I'd go away for perhaps six weeks while Jim Wolfe, Willard Beopple and Andre Fauteux – all young sculptors – would make them strong with good welds. Then I would come over to Canada and look again, working with a crane. I'd say, "let's have that side off" or "turn that over": often big changes. That was a good lesson for me, and I brought that lesson back to England. By making things rapidly, such as small sculptures in my garage, tacking them together and then not seeing them for six months, I could make spontaneous decisions. You look at the work afresh each time.

In these 'Flats' you show a very different appreciation of the steel, as a softer, malleable material with ragged edges, and you chose not to paint but to let them oxidize and then applied varnish. Were you moving away from a rather architectural approach to abstract sculpture and becoming more interested in the material itself?

Painterly, perhaps. The reason I had coloured them in the first place was to make them less arty, to make them look as if they did not come from an art background. But when people liked them too much, I thought, "now is the time that I must challenge myself".

The colours you chose to paint your sculptures in the 1960s were standard commercial colours?

Sheila had a say in the colours. She is great at that. The colours were chosen from Dulux charts, or whatever; they were not mixed specially for the sculpture.

You chose to use paint to deny the aesthetic quality of the steel, but people began to be seduced by the colour in itself?

I didn't mean them to be seduced by the colour. I wanted the works to be straight, just the sculpture. They had started off by being brown, and after a year or so I questioned that. When people started saying, "art should be like this", then you start to worry. You've got to question assumptions.

Is there a danger that you start to create new rules as you go along?

That's what happens, so you must switch.

So did you feel that a tradition was growing?

Whenever it's getting too easy, you have to challenge yourself.

And that seems to be a pattern throughout your career?

I hope so.

Staying with Canada, in 1977 you moved up to Emma Lake. Why is the 'Emma Lake' series, produced with very lightweight materials, such a contrast?

That's because at Emma Lake I was working in the middle of a forest. It was hours away from a scrapyard, so I had to work thin, light. These are materials that could be put in a truck. We'd use the crane on the truck to hold them in position.

Did you consider using the local natural materials? I ask because you get interested in wood later.

I wasn't in the least interested in anything pastoral, then or now.

The setting didn't influence the sculptures?

It influenced them insofar as I couldn't use heavy stuff. That was the influence.

What then drew you to Emma Lake?

"Try anything once", my father used to say, and when I was invited it seemed a good idea. There were a lot of young artists there and it was going to be interesting. A new place gives you new stimulation.

Beyond North America and Mexico you have travelled to Greece, India, Japan, Italy, France, Spain … .

I've never made sculpture in Greece. On one occasion I was asked if I would like to make art in Italy. I worked in a factory in Brianza, in northern Italy. I also worked in Barcelona. And I have made paperwork in Japan.

There seems to be a pattern here of seeking fresh inspiration through travel?

Very often. Change your environment to gain fresh stimulus. The steel is different.

Caro at the Emma Lake
Summer Workshops,
University of Saskatchewan,
Canada, 1977

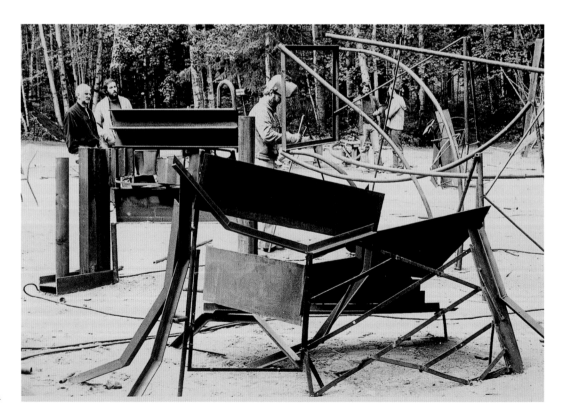

Caro selecting steel at the Ripamonte factory, Veduggio, Italy, 1972

The attitude is different. The people don't speak your language. So you're finding new things about yourself that you would never have found before. For instance, working in Barcelona in that bright sunlight and the strong linear shadows, you realize that those curly balustrades could become part of a new language and so you get an addition to your vocabulary.

And yet you were sixty-one when you went to Greece for the first time.

Yes, it was late in the day.

Had you avoided Greece?

Yes, I had.

Was that the Royal Academy's doing?

The tradition of thinking of Greece as part of an academy was a trap, a way into valuing bad art. Greek art was considered to be the right lesson. I didn't want the right way of doing things. I wanted to come to it myself. So I would not go there until I was ready. When I got there I was amazed at how utterly different it was from those Greek casts in the Royal Academy Schools, which are brown and dead. You need to see Greek art in the light of Greece. But in a museum so much of the art feels as if it's got a sort of glass case around it.

So Greece showed you sculpture in the wild?

Sculpture in the true.

In Greece you became particularly interested in pedimental sculptures, in how multi-part sculptures work together.

I was very impressed with the Temple of Zeus at Olympia. It is wonderful, the pediments and the metopes.

What attracted you to Indian sculpture? Was it on a holiday or were you invited to work there?

I had gone to Australia to judge a drawing competition, and India was a call on the way back. Later we went for a holiday for six weeks, and travelled all over. I was delighted with the Mughal architecture and Bombay, Delhi, Varanasi. I find Indian sculpture very sensual, very full in sculptural terms.

When you did the Trajan Markets exhibition in Rome in 1982, was that the first time you'd really spent some time in Rome?

Yes, I had been to Rome before. At that time I visited the Baths of Caracalla with Giovanni Carandente, and we'd talked about the idea of showing in Rome. Then years later, out of the blue, he said, "you should show in the Trajan Markets". I spent three marvellous weeks in Rome putting up the show and getting to know the city.

Was the actual arrangement of the sculptures in the Trajan Markets a work of art in itself, an installation, more than an exhibition?

The first morning I went in there I thought my sculpture looked terrible. Carandente suggested we had a spaghetti. And when we came back I gave the work a little twist and it looked just great. By that time I had mentally got out of grey English light and into the bright light of Rome. It was a different way of looking.

Having discovered the light of Rome, what took you the following year to Provence?

Eduardo Chillida had said, "you really should go to work with Hans Spinner in the south of France, you'll enjoy it". So I went.

Was it a real rediscovery for you of ceramic?

I had rediscovered ceramics two or three times.

Caro with Clement Greenberg, 1987

I worked with clay when I was a student: oily clay, modelling clay. I had worked with ceramics with Margie Hughto in Syracuse, USA: thin bowl-like ceramics and thin, flattened parts. I worked with pots and with more architectural flat planes with Paul Chaleff and with solid lumps with Hans Spinner. So they were all different sorts of ceramic rediscovery.

What were the particular qualities of ceramics that attracted you this time?

At Spinner's the massiveness. That's what I mean when I say how different the stimulus in each place is. Different people working in the same material work in quite different ways. Artists are wirelesses, listeners. Artists do a lot of taking in, as well as putting out.

How did the ceramics from Spinner's workshop evolve into *The Trojan War* in 1994?

By chance! When I made them I didn't know what I was doing. When they arrived in the studio here in Camden Town, fired hard, they were put out on the floor. They were parts of the warriors and the gods; they were *The Trojan War*. They told me who they were. I hadn't done figurative sculpture for years! But they said to me, "we are *The Trojan War*". I followed them. You listen to people and you listen to sculpture.

Was that the first time you'd combined ceramic with steel and wood?

Yes.

How did you know when a piece was ready, when it was finished?

An American friend of mine answers that question by saying, "when it says yes to you". When it's right.

Do some get chucked away?

Oh yes, lots. The failures go in the bin, and later I use the pieces.

With *The Trojan War* pieces there was a return to the figure, or the equivalent, the upright standing form, and with that an implied relationship with the viewer.

It was a narrative thing, something I hadn't done before. But it was not something so far from what I had been doing. When it was shown in Yorkshire, 10 miles away I was showing an abstract sculpture that you walked in among, and through. It was called *Halifax Steps – Ziggurats and Spirals*. I felt that you walk through the battlefield of *The Trojan War* and you walked through *Halifax Steps*. They were both about experiencing something in much the same way. One was like walking through architecture, and one was like walking through a battlefield.

How did your most epic work, *The Last Judgement*, follow on in 1999?

With *The Last Judgement* I knew where I was going. I didn't know they were going to be in those boxes. I found an old wardrobe and thought, "the pieces are going to fit in that". I had been to a church in Crete, a small church, the walls covered with saints and I thought, "that sort of thing is the feeling I'm after".

And what inspired you to make your last group, *The Barbarians*?

Sheila saw these gymnasium horses for sale on the pavement near King's Cross. She said, "Look at those, they're marvellous!" I bought three of them at once.

The latest major project, before this group you're working on now, was the Millennium Bridge across the Thames. How did that come about?

Several people had said to me, "why don't you go in for the Millennium Competition? They want to have a mixture of architects, artists and engineers." So I rang Norman Foster. We worked together with Chris Wise, the engineer. To my amazement we were short-listed, and to my utter amazement we won. Of course, we didn't build just what we sent in; we built something different, but this is how it goes. I didn't understand the difficulties of being an architect; they are immense. And wading through the rules and objections is a nightmare. Norman does it very well, thank goodness. He manages to persuade committees and so on. It all worked out well in the end, but it was not easy, and even Norman regards it as one of the most difficult projects he's ever done.

What were the rewards of working with Norman Foster?

I have learned a lot from working with architects. They are more conceptual; they think a lot on paper. They can envisage and they've got a great sense of scale. They use repetition and keep things big and simple. They have a feeling for open air.

The Millennium Bridge,
London, 2000

What do you feel you brought to the creative process behind the Millennium Bridge?

Lateral thinking. You throw in a spanner. Chris Wise, the engineer, saw the bridge like a guitar string stretched across the river, and so it was planned. I've enjoyed working with architects, and it's broadened my approach.

So, looking ahead, are there other projects on the horizon? At eighty, what's still driving you? Is it something that you're trying to achieve, or is it a sort of restlessness? Most people would be putting their feet up by now. You just keep on making things.

Who wants to put their feet up? The studio is where I'm really happy, and for Sheila it's the same. When we come home at the end of a good day's work, we both agree it's been a delight. Making art is what my life's been about, and it still is.

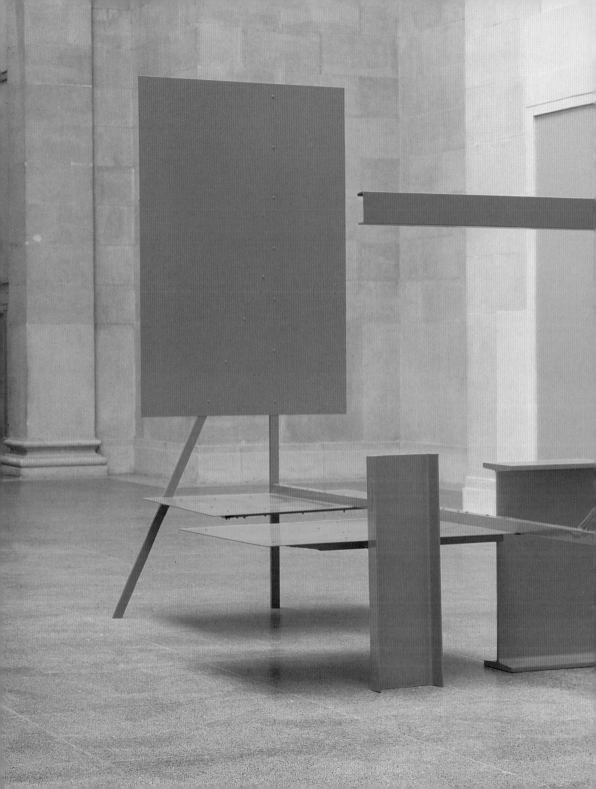

Fifty Years of Sculpture

Midday, 1960
Caro's first trip to America, in
1959–60, inspired him to make
sculptures that were not
representative of a figure but
were significant in their own right,
as real as the viewer, standing
on the same ground without
a pedestal

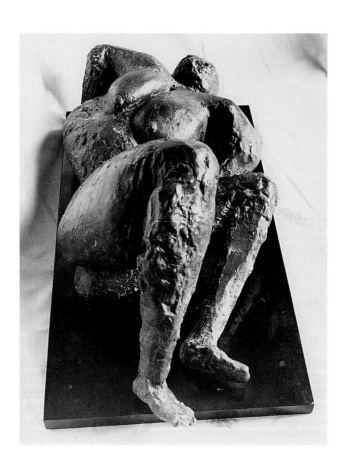

Woman Waking Up, 1955
After working as Henry Moore's assistant, Caro sought to express through
sculpture the sense of being inside a body; here he explores the sense of
being grounded by gravity

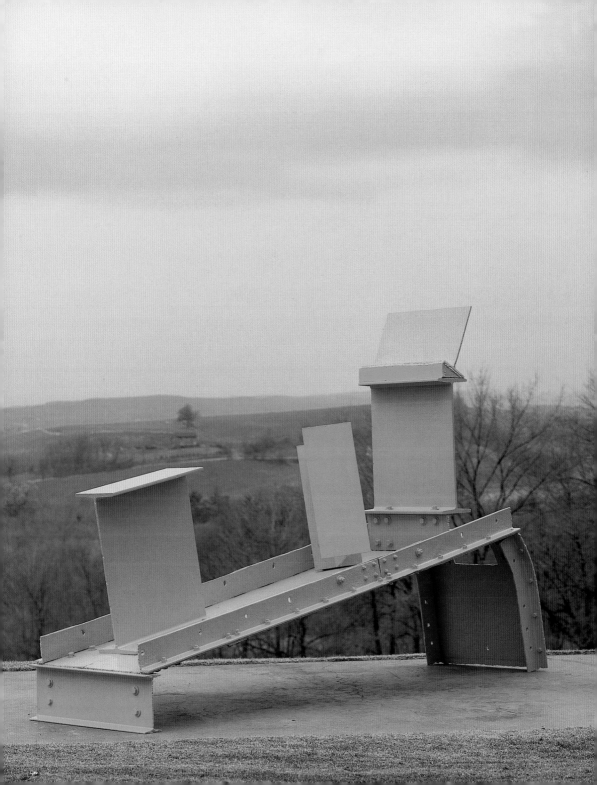

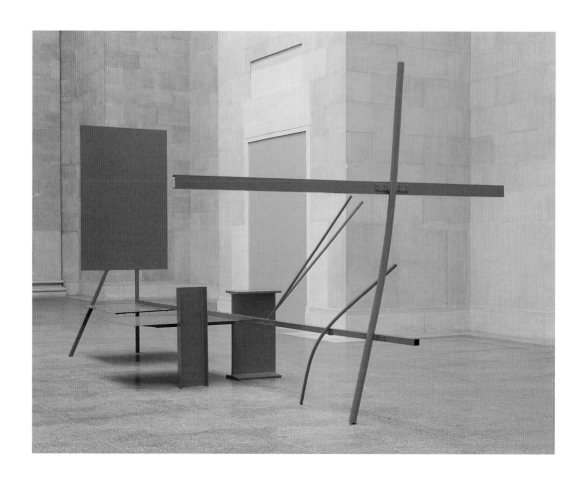

Early One Morning, 1962

Caro's best-known work, *Early One Morning* has all the grace of a winged Nike dancing,

and the energy of fighters flying off an aircraft carrier

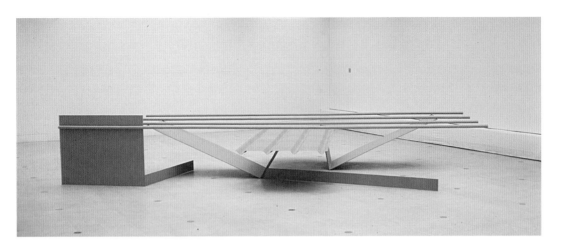

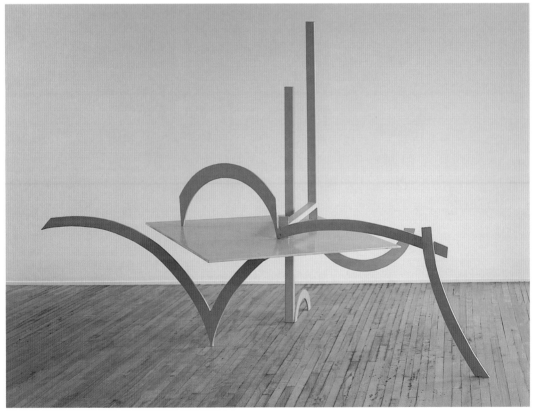

Trefoil, 1968

Dancing rhythms hold a single plane in perfect balance above the floor 65

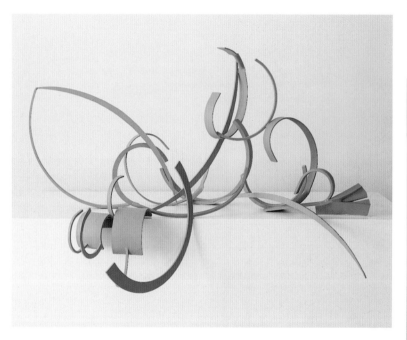

Table Piece LXXXVIII 'Deluge', 1969

Inspired by a drawing of eddying currents by Leonardo da Vinci in The Royal Collection,

66 *Deluge* is from a series of 'table pieces'; each one teases the limits of equilibrium

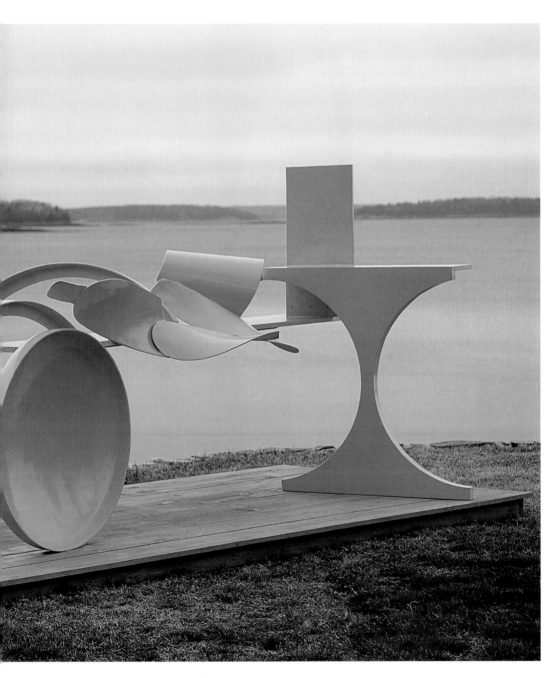

Sun Feast, 1969–70
Soloist and supporters, sprightly and heavier rhythms, combine in this visual concerto 67

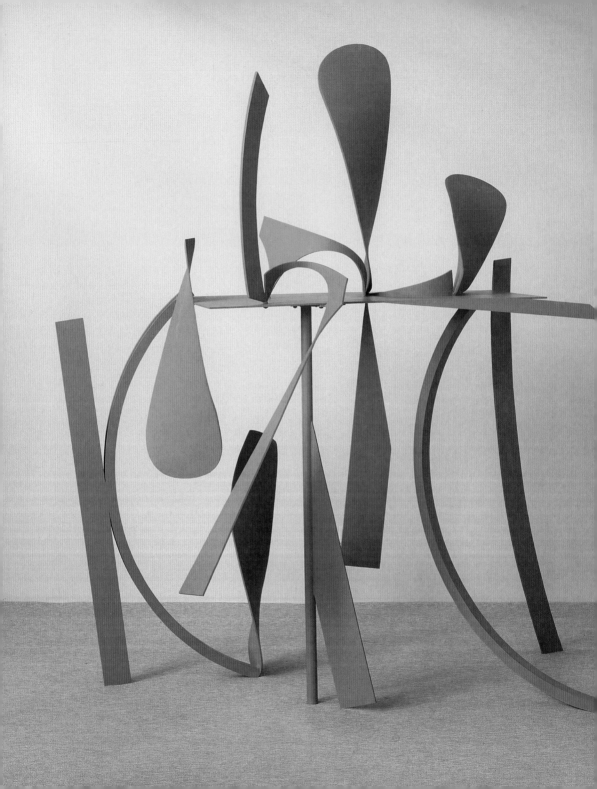

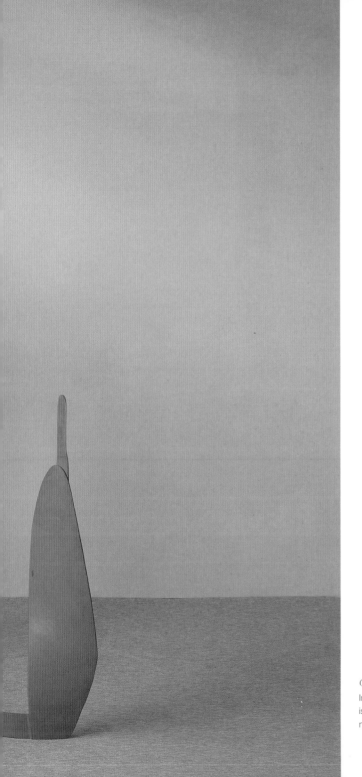

Orangerie, 1969
In this whirling dance for the eyes the viewer
is led on, through, under and over an infinite
number of choreographed steps

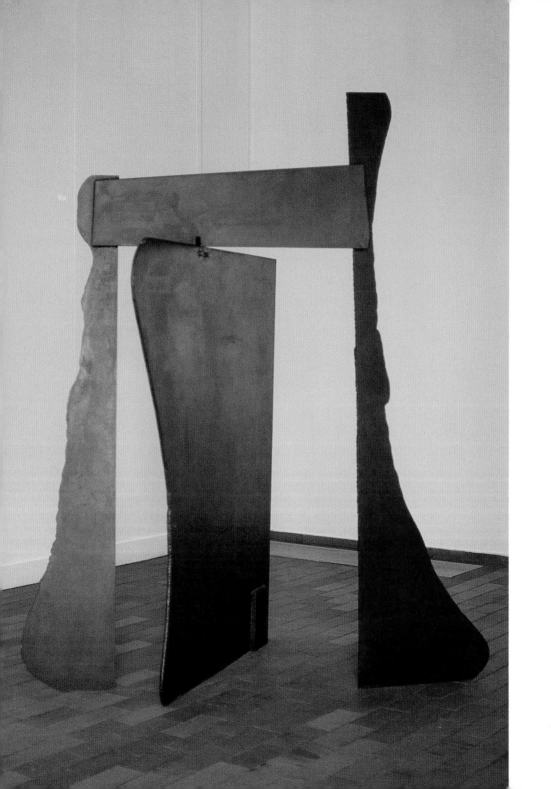

Veduggio Sound, 1972–73
Caro describes this as "a drawing in
steel made in Italy, where the light is
strong and the shadows deep"

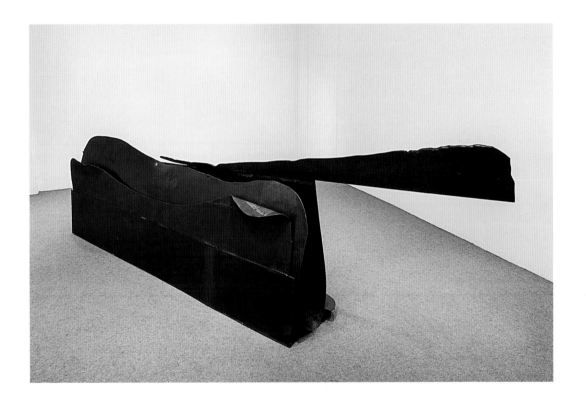

Durham Purse, 1973–74
The series of varnished, rusted works made from roll-end steel in the 1970s are in
marked contrast to the colourful, open, optimistic sculptures of the 1960s. These
sculptures owe much of their folds and silhouettes to the factory production
processes of rolling and trimming steel while it is still pliable from the furnace

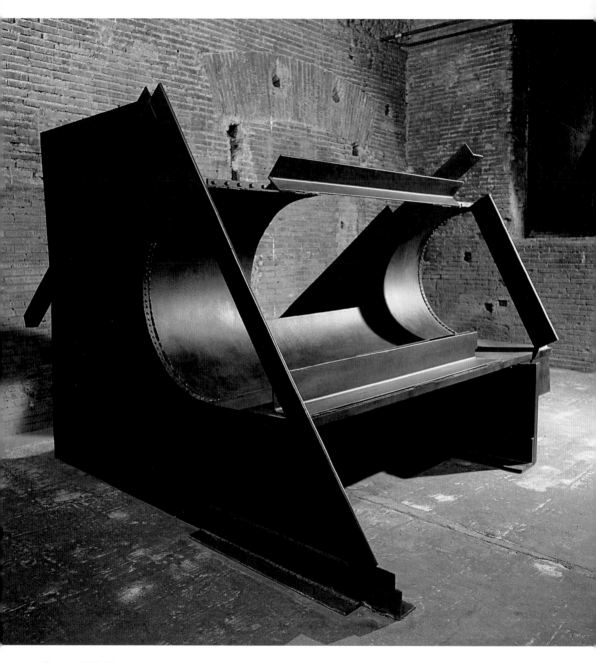

Roman, 1970–76
Volume, as sculpted space, can be both contained within a solid silhouette
and captured within the embrace, as here, of an open cylinder

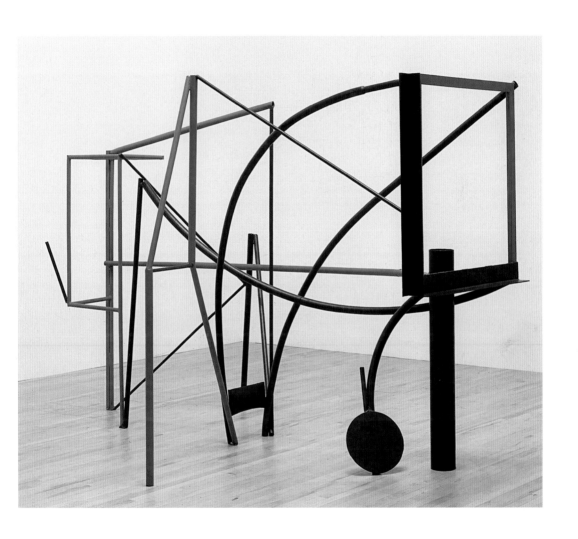

Emma Dipper, 1977
Drawing in space, Caro creates a sculpture with no surface or
centre, a volume indicated only by the intersections of its edges,
a sculpture whose mass exists only in the air and the eye 73

Child's Tower Room, 1983–84
'Sculpitecture' is the term Caro
coined to describe works that
cross the boundaries between
sculpture and architecture; here
the sculpture recalls a child's
tree house

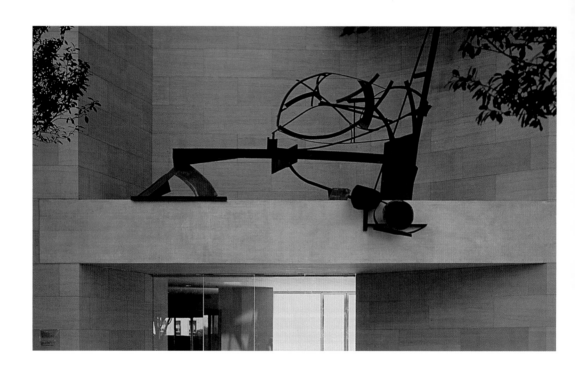

National Gallery Ledge Piece, 1978
This architectural overdoor stands in the National Gallery of Art, Washington D.C.,
in the East Wing designed by I.M. Pei. As a commission for sculpture for a public
building it is unique in Caro's œuvre

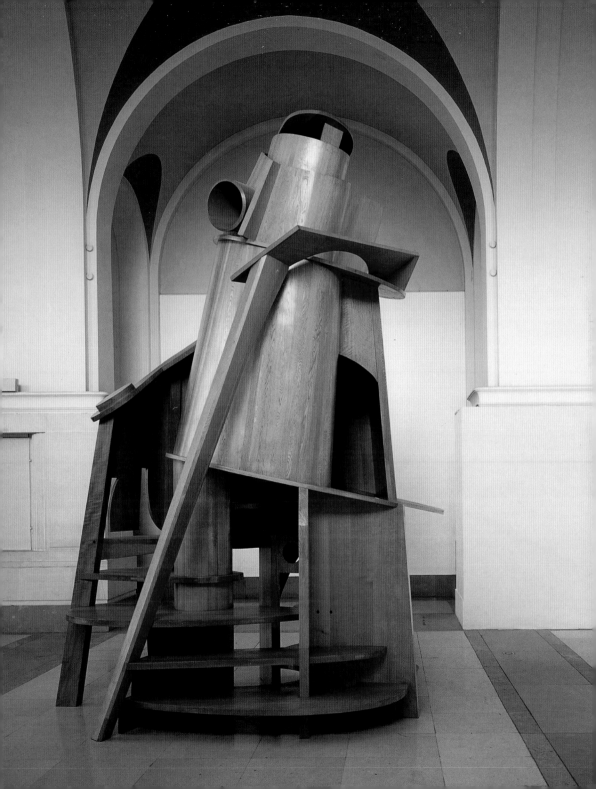

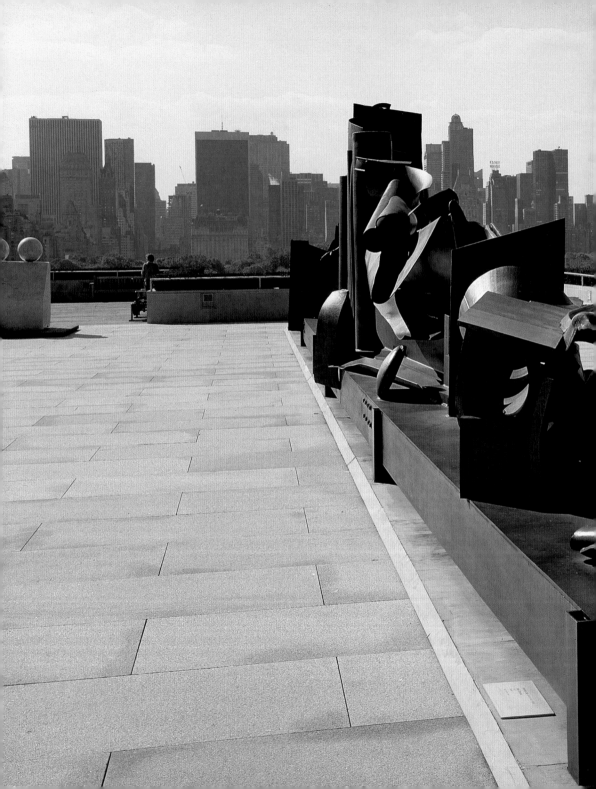

After Olympia, 1986–87
Visiting Greece for the first time, in 1985, Caro was fascinated by the pedimental sculpture of ancient temples, particularly the way in which the viewer explores the multiple figural compositions as if passing a procession. This long, triangular group, based on the west pediment sculpture from the Temple of Zeus at Olympia, was first shown on the roof terrace of The Metropolitan Museum of Art in New York in 1988

Working Model for Lakeside Folly, 1988
In 1987 Caro collaborated with the architect Frank Gehry to create a temporary 'village'
of loose, sculptural architectural forms (that survive only in photographs), from which this
half-scale project developed the following year

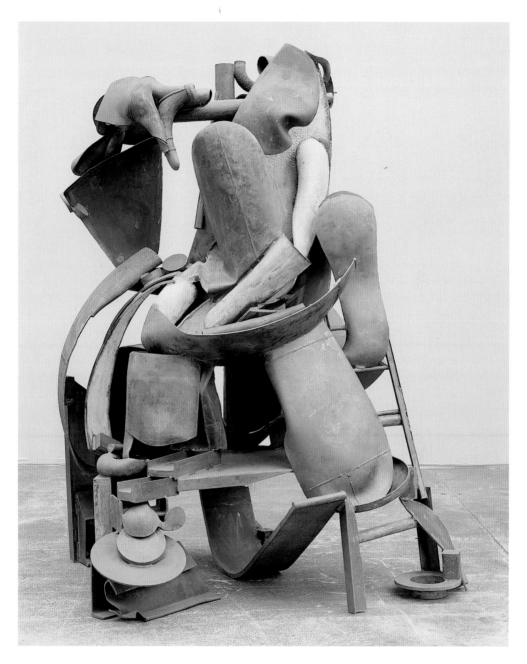

Descent from the Cross (after Rubens), 1989
The structure of a crucifix provides the internal geometry from which softer
forms flow, as in an altarpiece by Rubens

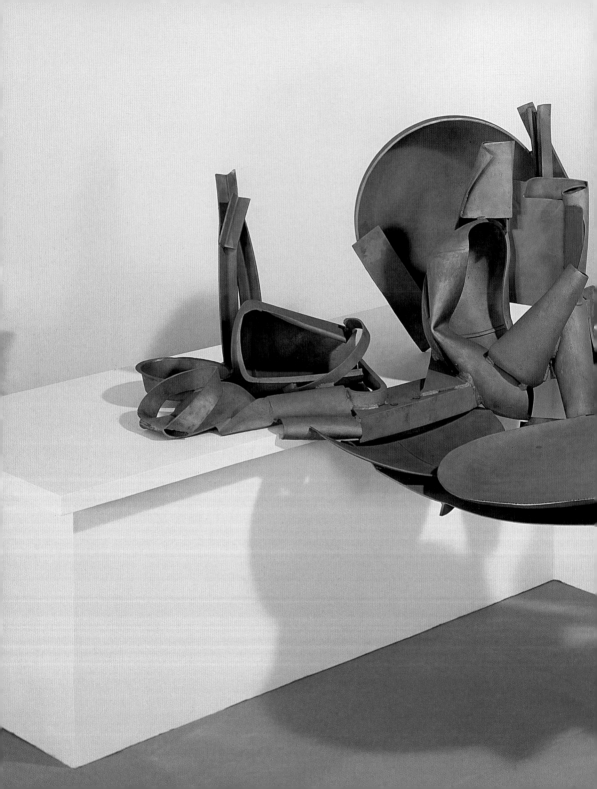

Déjeuner sur l'herbe II, 1989
Manet's masterpiece provided
the point of departure for this
'table-piece' that spans a corner 81

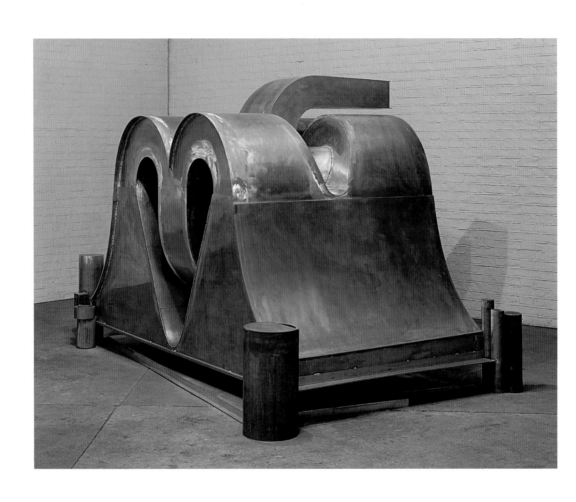

Elephant Palace, 1989
A broken Roman bronze bust gave Caro the idea of exploring sculpture as 'skin',
with both external and internal surfaces

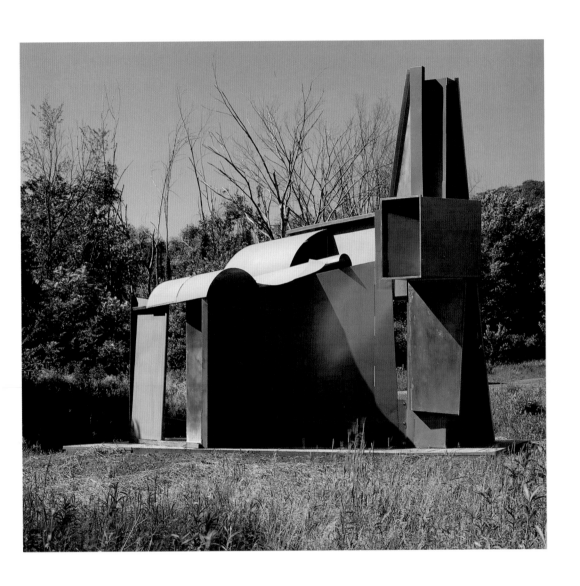

Cathedral, 1988–91
One of Caro's most architectural pieces, this work, made in
New York State, uses thin sheets of steel over constructed supports 83

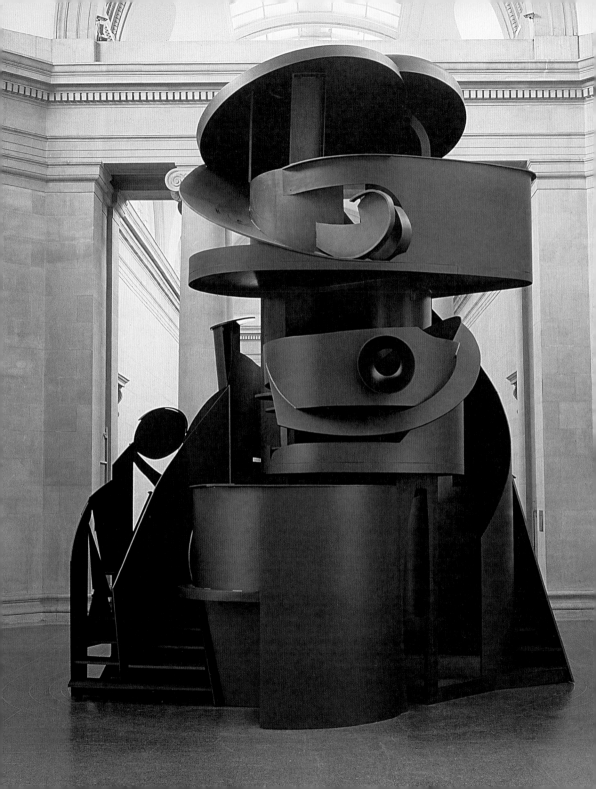

Tower of Discovery, 1991
An answer to *Child's Tower Room* (1983–84), this
monumental steel 'sculpitecture' was created for initial
display in the central octagon of the Tate Gallery, London

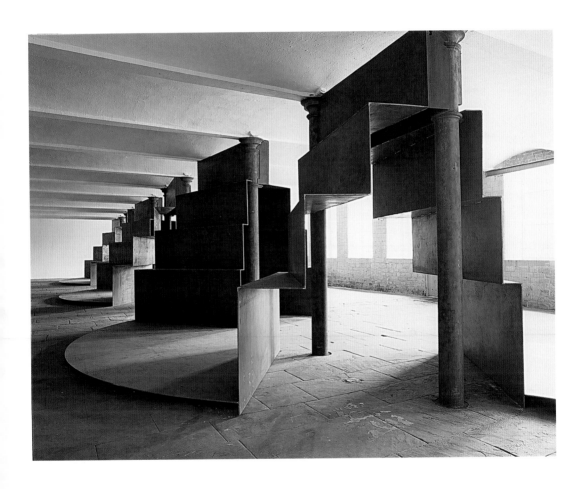

Halifax Steps – Spirals, 1994–95
A single architectural element repeats through a series
of reversals like a flowing river snaking back on itself

The Last Judgement, 1995–99
This dramatic installation of twenty-five
elegiac sculptures was Caro's most
expressionistic work to date, fuelled
by the horrors of "man's inhumanity
to man" in the modern world

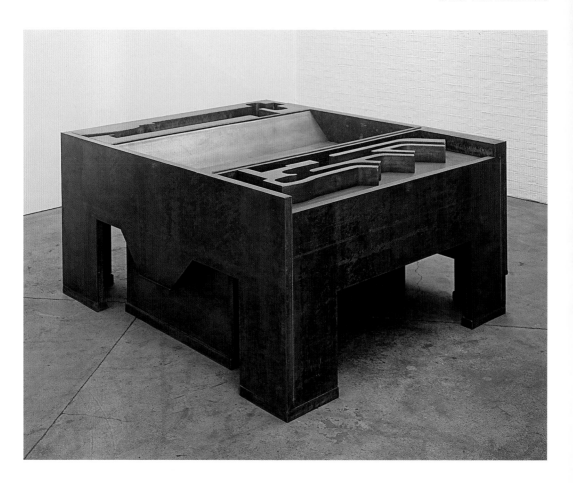

Night and Dreams, 1990–91
This massive architectural table unites many of the
formal themes of sculpture explored by Caro

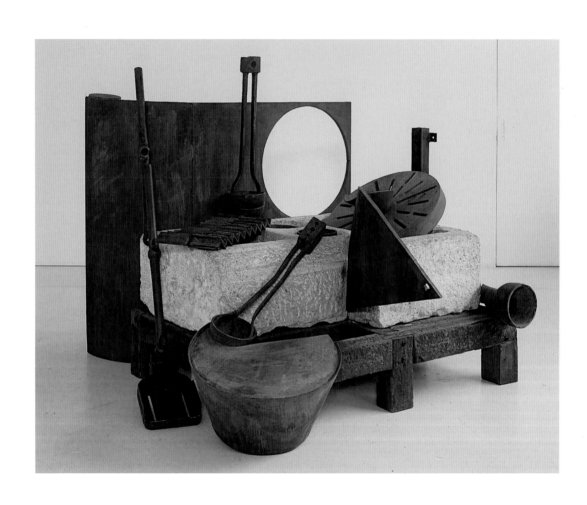

Music Table, 2003–04

A stone trough found in France evolved into this composition in which musical instruments seem to await their Arcadian players

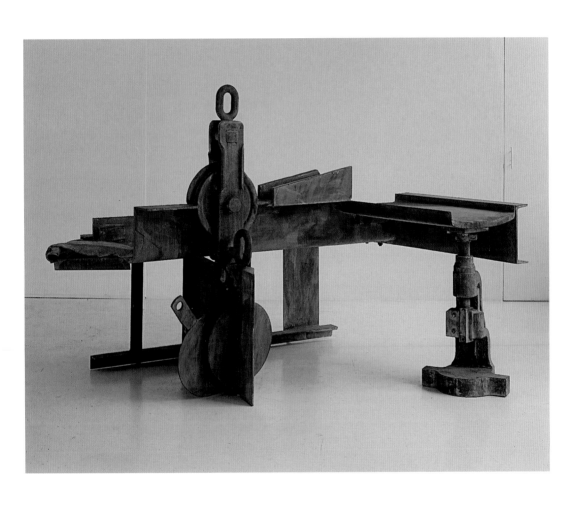

Crypt, 2003–04
Large and heavy machine parts are left
recognisable in a 'table-piece' over caged space 89

Checklist of Illustrated Sculptures

1924 Born, New Malden, Surrey, England

1937–42 Charterhouse, Surrey

1942–44 Christ's College, Cambridge University. Degree in Engineering

1944–46 Royal Navy, Fleet Air Arm. Engineer

1946–47 Regent Street Polytechnic, London. Studies sculpture

1947–52 Royal Academy Schools, London. Studies sculpture

1949 Marries fellow student, the painter Sheila Girling

1951–53 Assistant to Henry Moore, part-time

1953 Starts teaching part-time, St Martin's School of Art, London (retires 1979)

1954 Moves from Much Hadham, Hertfordshire, to Hampstead, north London. Models figures in clay and plaster; several cast in bronze

1956 Galleria del Naviglio, Milan: first one-man exhibition

1957 Gimpel Fils Gallery, London: first one-man exhibition in UK

1959 Tate Gallery, London, buys *Woman Waking Up* (1955). Paris Biennale: wins sculpture prize for young artists. Meets Clement Greenberg in London

1959–60 Visits USA: meets David Smith, Kenneth Noland, Helen Frankenthaler, Robert Motherwell and others in New York. Travels to Los Angeles and Mexico

1960 Sets up welding workshop at St Martin's

1961 First polychrome sculptures, assisted by Sheila Girling

1962 *Early One Morning*

1963 Whitechapel Art Gallery, London: one-man exhibition of abstract painted steel sculptures, without pedestals

1963–65 Teaches at Bennington College VT

1964 André Emmerich Gallery, New York: first one-man exhibition in USA. Begins making sculpture in series

1966 First 'table sculptures'

1967 Kröller-Müller Museum, Otterlo: retrospective exhibition

1969 Hayward Gallery, London: retrospective exhibition. New studio in former piano factory, Camden Town, London. Patrick Cunningham joins as full-time technical assistant. *Table Piece LXXXVIII 'Deluge', Orangerie* and *Sun Feast* (1969–70)

1970 Makes 'table pieces', using edge of table. Makes unpainted steel sculptures in Kenneth Noland's studio, Shaftesbury VT

1972 Ripamonte Factory, Veduggio, Brianza, Italy: uses roll-end steel to make *Veduggio Sound* and other works

1973 Consett, Co. Durham: uses soft-edged rolled steel to make *Durham Purse* and other works

1974 York Steel Co., near Toronto, Canada: makes 'Flats' series, using larger, heavier sheets of rolled steel, assisted by mobile cranes

1975 The Museum of Modern Art, New York, holds retrospective exhibition (which travels to Minneapolis, Houston and Boston). Collaborates with ceramicist Margie Hughto at Syracuse University NY

1977 University of Saskatchewan, Emma Lake, Canada: artist in residence. Produces *Emma Dipper* and other works

1978 Commission for sculpture for new East Wing of National Gallery of Art, Washington, D.C. Produces 'writing pieces': calligraphic steel sculptures incorporating tools and utensils

1981 Bedford NY: collaborates with Ken Tyler in producing 'wall pieces' from hand-made paper

1982 Pine Plains NY: founds, with Robert Loder, the Triangle Workshop for painters and sculptors (participates annually until 1991)

1983–84 First architectural sculpture: *Child's Tower Room*

1984 Serpentine Gallery, London: one-man exhibition (travels to Manchester, Leeds, Copenhagen, Düsseldorf and Barcelona). *The Moroccans* (1983–87)

1985 First visit to Greece

1986–87 Produces largest sculpture to date, *After Olympia*

(shown on roof garden of The Metropolitan Museum of Art, New York, 1988)

1987 Barcelona: participates in Triangle Workshop of artists

1988 'Catalan' series of sculptures

1989 'Barcelona' and 'Catalan' series shown at Sala de Exposiciones Banco de Bilbao, Vizcaya, Barcelona. Visits South Korea and India. Retrospective exhibition at Walker Hill Art Center, Seoul.
Elephant Palace and *Déjeuner sur l'herbe*

1990 *Night Movements*. Makes series of paper sculptures at Nagatani's workshop, Obama, Japan. Musée des Beaux-Arts et de la Dentelle, Calais: retrospective exhibition

1991 *Tower of Discovery* for Tate Gallery, London, exhibition of recent works *Sculpture into Architecture*. *Sea Music* made for quayside, Poole, Dorset

1992 Retrospective exhibition at Trajan Markets, Rome

1993 Works with ceramicist Hans Spinner in Grasse, Provence, France

1994 *The Trojan War*, forty-part group of sculptures exhibited at The Iveagh Bequest, Kenwood, London (travels to Yorkshire Sculpture Park, Wakefield; The French Institute, Thessaloniki; National Gallery of Greece, Athens; and Marlborough Fine Art, New York). Also shown at Museum of Contemporary Art, Tokyo, in largest retrospective to date

1994–95 *Halifax Steps – Ziggurats and Spirals* commissioned as a temporary sculpture for the Henry Moore Studio, Dean Clough, Halifax, Yorkshire

1997 Openluchtmuseum voor beeldhouwkunst, Middelheim, Belgium, holds retrospective exhibition

1998 National Gallery, London, exhibition *Sculpture from Painting*, the gallery's first exhibition by a contemporary sculptor

1999 *The Last Judgement*, twenty-five-part sculpture (begun 1995) shown at 48th Venice Biennale

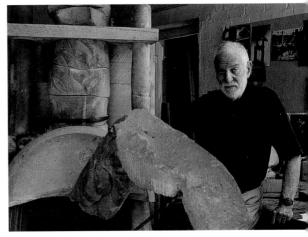

Caro working on *Jiloo* from *The Barbarians*, 2002

2000 *The Last Judgement* comprises the first show in the Museo de Belles Artes, Bilbao, and is subsequently shown at the Johanniter Kirche, Schwäbisch Hall, Germany, 2001, and at Fundació Caixa Catalunya, Barcelona, 2002. Millennium Footbridge across River Thames, in collaboration with Norman Foster and Chris Wise

2002 *The Barbarians* (begun 1999) exhibited, Annely Juda Fine Art, London, and Mitchell-Innes & Nash, New York. Retrospective exhibition at Fundació Caixa Catalunya, Barcelona

1959	Sculpture Prize, First Paris Biennale	1994	Honorary Doctorate, Royal College of Art, London
1966	David E. Bright Foundation Prize, Venice Biennale	1996	Chevalier de l'Ordre des Arts et des Lettres, awarded by the French Republic

1959 Sculpture Prize, First Paris Biennale

1966 David E. Bright Foundation Prize, Venice Biennale

1968 Honorary Doctor of Letters, University of East Anglia

1969 Commander of the Order of the British Empire Prize-winner, São Paulo Biennial

1976 Presented with key to New York City by Mayor Abraham Beame

1979 Honorary Member of American Academy and Institute of Arts and Letters
Honorary Doctor of Letters, York University, Toronto

1981 Honorary Degree, Brandeis University MA
Honorary Fellow, Christ's College, Cambridge University

1981–83 Member of Council, Royal College of Art, London

1982–89 Trustee, Tate Gallery, London

1982 Member of Council, Slade School of Art, University of London

1985 Honorary Doctor of Letters, Cambridge University

1986 Honorary Fellow, Royal College of Art, London

1987 Honorary Degree, University of Surrey
Knight Bachelor, Queen's Birthday Honours

1988 Honorary Foreign Member, American Academy of Arts and Sciences

1989 Honorary Fine Arts Degree, Yale University

1990 Honorary Fine Arts Degree, University of Alberta, Edmonton, Canada

1991 Honorary Fellow, Wolfson College, Oxford University
The Henry Moore Grand Prize and the First Nobutaka Shikanai Prize, Hakone Open-Air Museum, Tokyo

1992 Honorary Member, Accademia di Belle Arti di Brera, Milan
Praemium Imperiale Award for Sculpture, Japan Art Association, Tokyo

1993 Honorary Doctor of Letters, Winchester School of Art, University of Southampton

1994 Honorary Doctorate, Royal College of Art, London

1996 Chevalier de l'Ordre des Arts et des Lettres, awarded by the French Republic
Doctor Honoris Causa, Université Charles-de-Gaulle, Lille, France
Honorary Doctor of Letters, Durham University

1997 Lifetime Achievement Award, International Sculpture Center, Hamilton NJ
Honorary Fine Arts Degree, Florida International University
Honorary Fellow, Royal Institute of British Architects, London
Honorary Fellow, Royal Society of British Sculptors, London

1998 Honorary member of Board of Trustees, International Sculpture Center, Hamilton NJ
Honorary Fellow, Glasgow School of Art
Honorary Fellow, Bretton Hall College, University of Leeds

1999 Honorary Doctor of Letters, University of Westminster, London

2000 Appointed to the Order of Merit by HM Queen Elizabeth II

2004 Honorary Fellowship, University of the Arts, London
Senior Royal Academician

Select Bibliography

A more comprehensive bibliography may be found in the Tokyo 1995 catalogue.

Monographs

Richard Whelan, *Anthony Caro*, Harmondsworth 1974

William Rubin, *Anthony Caro*, London 1975 [English edition of the catalogue for the retrospective exhibition at The Museum of Modern Art, New York, 1975]

Dieter Blume, *Anthony Caro: A Catalogue Raisonné*, 13 vols, Cologne 1981–2001

Diane Waldman, *Anthony Caro*, Oxford 1982

Terry Fenton, *Anthony Caro*, London 1986

Ian Barker (ed.), *Caro*, Munich 1991 [text by Karen Wilkin, photographs by John Riddy]

Shigeo Anzaï, *Caro by Anzaï*, Tokyo 1992 [a photo-essay]

Giovanni Carandente, *Caro at the Trajan Markets*, Rome, ed. Ian Barker, London 1993

Julius Bryant and John Spurling, *The Trojan War: Sculptures by Anthony Caro*, London 1994

Ian Barker (ed.), *The Last Judgement Sculpture by Anthony Caro*, Künzelsau 1999

Ian Barker, *Anthony Caro: Quest for the New Sculpture*, London 2004

Exhibition Catalogues

Caro and Gravity, Milan, Galleria del Naviglio, 1956 (article by Lawrence Alloway)

Anthony Caro, London, Whitechapel Gallery, 1963 (article by Michael Fried)

American Sculpture of the Sixties, Los Angeles County Museum of Art, 1967 (article by Clement Greenberg)

Anthony Caro, 1954–1968, London, Hayward Gallery, 1969 (article by Michael Fried)

Anthony Caro: Sculpture 1969–1984, London, Serpentine Gallery, 1984 (article by Tim Hilton)

Anthony Caro, London, Knoedler and Waddington Galleries, 1986 (article by David Sylvester)

Aspects of Anthony Caro: Recent Sculpture, 1981–1989, London, Annely Juda Fine Art, 1989 (article by Richard Rogers)

Anthony Caro: Sculpture towards Architecture, London, Tate Gallery, 1991 (article by Paul Moorhouse)

The Cascades, London, Annely Juda Fine Art, and New York, André Emmerich Gallery, 1991 (article by Ken Johnson)

Anthony Caro: The Obama Paperworks, Tokyo, Fuji Television Gallery, 1992 (articles by Ian Barker and Shigeo Anzaï)

Anthony Caro: Five Decades, London, Annely Juda Fine Art, 1994 (article by Bryan Robertson)

Anthony Caro, Tokyo, Museum of Contemporary Art, 1995 (articles by Yasuyoshi Saito, Tadayasu Sakai and Seiji Oshima)

Halifax Steps, Halifax, Henry Moore Sculpture Trust Studio, 1995 (article by Robert Hopper)

The Caros: A Creative Partnership – Sheila Girling and Anthony Caro, Portland, Dorset, Chesil Gallery, 1996 (article by Julie Summers)

Anthony Caro: Ceramic Sculpture, New York, Garth Clark Gallery, 1998 (article by Garth Clark)

Anthony Caro: New Sculptures – A Survey. Caro, Foster, Wise: The Millennium Bridge Project, London, Annely Juda Fine Art, 1998 (article by Phyllis Tuchman)

Caro at the National Gallery: Sculpture from Painting, London, National Gallery, 1998 (article by John Golding)

El Juicio Final: Anthony Caro, Bilbao, Museo de Bellas Artes, 2000 (articles by Francisco Calvo Serraller and Giovanni Carandente)

Duccio Variations, Gold Blocks, Concerto Pieces, New York, Marlborough Gallery, 2001 (article by Richard Morphet)

Caro at Longside: Sculpture and Sculpitecture, Wakefield, Yorkshire Sculpture Park, 2001 (articles by Peter Murray and Anthony Caro)

Anthony Caro: The Barbarians, London, Annely Juda Fine Art, and New York, Mitchell-Innes & Nash Gallery, 2002–03 (article by Dave Hickey)

Anthony Caro: Drawing in Space. Sculptures from 1963 to 1988. The Last Judgement, 1995–1999, Barcelona, Fundació Caixa Catalunya, 2002 (articles by Anthony Caro, Enrique Juncosa, Pep Subirós and Eugenio Trías)